CHURCHES OF
CHESHIRE

DAVID PAUL

AMBERLEY

This edition first published 2023

Amberley Publishing
The Hill, Stroud
Gloucestershire GL5 4EP

www.amberley-books.com

British Library Cataloguing in Publication Data.
A catalogue record for this book is available from the British Library.

ISBN 978 1 3981 1059 5 (print)
ISBN 978 1 3981 1060 1 (ebook)

Typesetting by SJmagic DESIGN SERVICES, India.
Printed in Great Britain.

CONTENTS

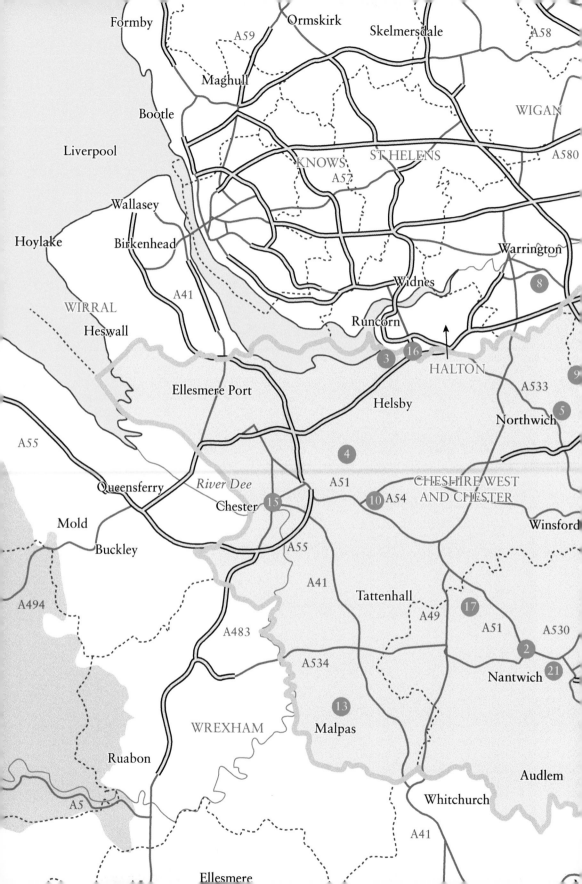

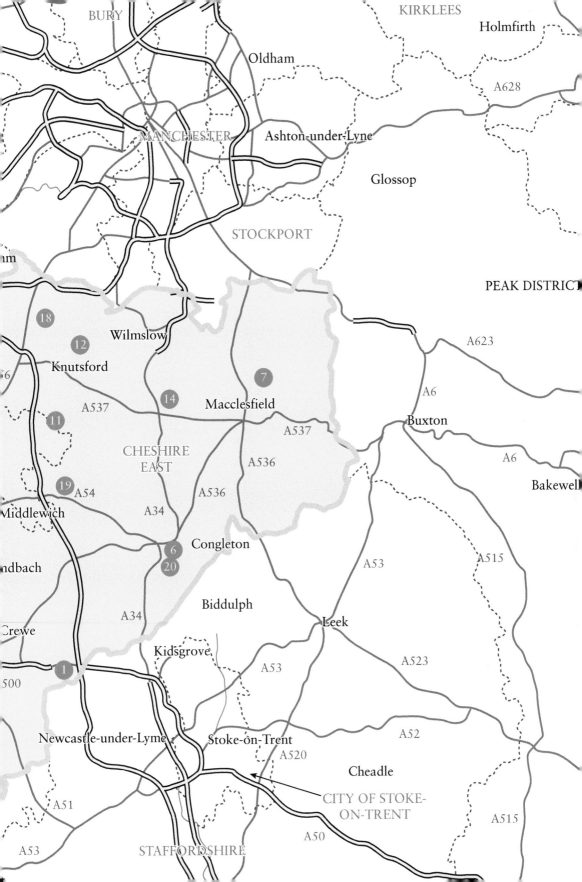

INTRODUCTION

In this book I have endeavoured to include a wide cross-section of Grade I listed churches in Cheshire. The task was not without its difficulties as there are in excess of forty such churches across the county, ranging from the grandeur, elegance and sheer beauty of St Mary and All Saints' Church at Great Budworth, or the parish church of St Mary's at Nantwich, to the relative simplicity and understated dignity of St Peter's at Aston-by-Sutton or St Helen's Church at Northwich. A number of different styles of architecture can be seen in the twenty-one Grade I listed churches featured in the text, with many dating from the Norman period or even earlier.

During the twelfth century the old Norman style of architecture was gradually being replaced in by the Gothic, which had its origins in north-west France. English Gothic architecture flourished between around 1180 and 1520. The three predominant styles included Early English Gothic, which dated from around 1180 to 1250; Decorated Gothic, which was fashionable between 1250 and 1350; and Perpendicular Gothic, which dated from 1350 to 1520. Early English Gothic is characterised by pointed arches or lancets. In addition to using pointed arches in wide-span arches such as the nave arcade, lancet design was used for doors and, more often, stained-glass windows. Decorated Gothic is characterised above all by the tracery on the stained-glass windows. Design innovations enabled increasingly elaborate windows to appear, separated by narrowly spaced parallel mullions. Perpendicular Gothic is characterised by a predominance of vertical lines, which is most noticeable in the stone tracery of the windows. This is demonstrated to its best effect in the design of enlarged windows, utilising slimmer stone mullions than was possible in earlier periods, thus giving greater flexibility for stained-glass craftsmen.

Also, because of various nationwide difficulties that occurred during construction, such as the English Civil War, the Reformation or the bubonic plague, many of the churches described incorporate a number of different architectural styles, indicating that the building work took many years to complete and evolved during that time. Similarly, it was not unheard of for a church benefactor to have the church rebuilt or substantially modified to conform to contemporary ecclesiastical fashion or personal cupidity.

The book does not purport, in any way, to be an academic text, but is aimed at the general reader.

David Paul

1. St Bertoline's Church, Barthomley

The tower and nave of St Bertoline's Church date from the late fifteenth century. The Crewe Chapel was built around 1528. The church was restored between 1852 and 1854. Then, between 1925 and 1926, the Marquess of Crewe commissioned a new chancel to be built as a memorial to his family.

The oldest part of this predominantly Perpendicular-style church is a Norman blocked doorway, situated in the north wall in a space between the end of the aisle and the vestry. St Bertoline's has a four-bay nave with north and south aisles – the Crewe Chapel being situated at the east end of the south aisle – a north porch, a clerestory, a chancel with a vestry to its north and the west end tower. The tower is embattled at its summit and has eight crocketed pinnacles and gargoyles at the four corners. The original stone holy water font is located in the church porch. Both the camber beam-panelled roofs of the nave and north aisle date from the sixteenth century.

During the restoration of the church between 1852 and 1854, many of the treasured fittings were lost, but the parclose screen, which divided the Crewe Chapel from the chancel, was preserved. The west window, which dates from 1873, is by the London firm of Clayton and Bell. The east window, which is much later (1925), is by Shrigley and Hunt. The Elizabethan altar has two panels; the right-hand panel depicts the Flight from Egypt, whereas the panel on the left

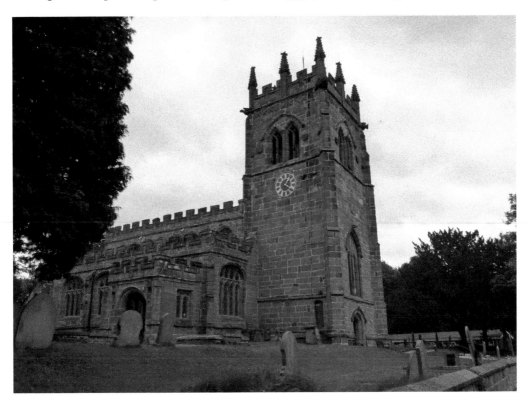

Parish church of St Bertoline, Barthomley.

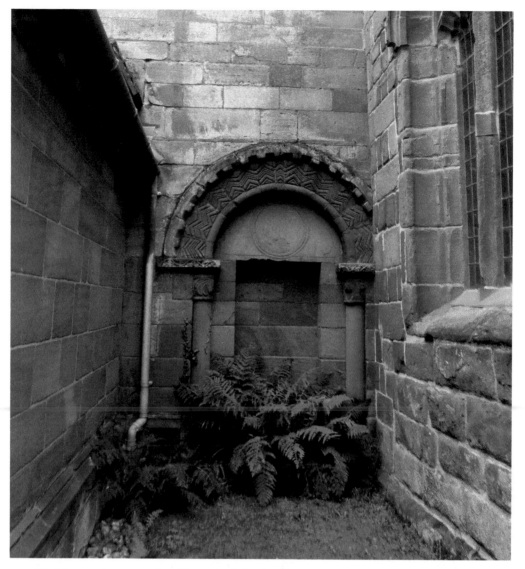

The Norman doorway – the oldest part of the church.

shows a Nativity scene with two shepherds bringing gifts for the baby Jesus, one bringing a hare and the other bringing a bird.

The Crewe Chapel was built at the beginning of the seventeenth century by Sir Ranulph Crewe. There are several alabaster tombs within, including the tomb of Sir Robert de Foulshurst (Fulleshurst), who fought at the Battle of Poitiers in 1356. There is also the tomb and effigy of another Robert Fulleshurst: he was rector here before the time of the Reformation, and, because he was a Roman Catholic, it was considered prudent to hide his tomb in a recess in the wall of the chapel.

Crafted by the queen's sculptor, Sir Joseph Boehm, in the middle of the chapel there is the tomb and white marble figure of Lady Sybil Marcia Houghton, first wife of the 2nd Baron Houghton – she died just seven years after they had been married.

St Bertoline's originally had a peal of six bells, which were cast by Rudhall of Gloucester between 1743 and 1747. The bells were recast in 1908 by Taylor of Loughborough, when their number was increased to eight.

The chancel arch was widened and heightened during the twentieth century under the direction of the Lancastrian architects Paley and Austin, who also replaced the roof and the east and north windows. Christ in Glory is depicted in the memorial window above the altar.

The original church clock was made by the village smith in 1710, and only needed to be replaced as recently as 1934, when the present clock was donated by the rector at that time, Revd Armistead.

Forster & Andrews of Hull built and installed the original organ in 1850. Restoration was carried out by Ward & Shutt in 1969 and again in 2003. In 2005, this organ was replaced by a Makin digital organ.

Unfortunately, Barthomley, and more particularly St Bertoline's Church, was the scene of one of the most horrendous and notorious massacres in the history of the Civil War. Although the Parliamentarians controlled much of the county of

Above left: Looking towards the nave and east window.

Above right: Looking towards the west window.

Cheshire, the Royalists, having been strengthened by a contingent arriving from Ireland towards the end of 1643, decided to seize the initiative and actively seek locations where the Parliamentarians held sway. Two days before Christmas, on 23 December 1643, Royalist troops marched on the village.

The contemporaneous account of the confrontation states that some twenty 'neighbours' sought refuge in the church, but that the Royalist pursued them into the church, forcing the 'neighbours' to climb into the church steeple. The marauding troops then set a fire, burning 'formes, pewes, Rushes & the lyke', whereupon the besieged 'neighbours' 'called for quarter, & yelde theim selves'. The troops' commander, Major Connaught, having secured ascendency, then decided against granting the amnesty – perhaps, as is recorded in some accounts, because of the fact that the rector's son, John Fowler, fired on the soldiers, killing one of them, and provoking Connaught's reaction. 'Hee caused theim all to be

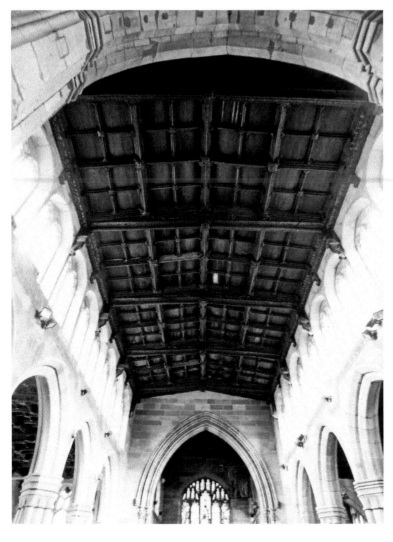

The Foulshurst family built the oak ceiling.

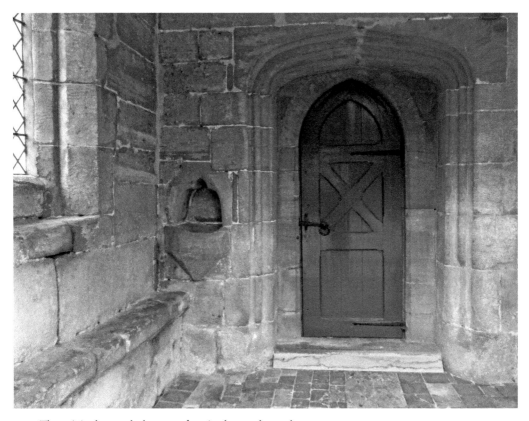

The original stone holy water font in the north porch.

stripped starke Naked; And moste barbarouslie & contr[ar]y to the Lawes of Armes, murthered, stabbed and cutt the Throates of xii of theim;...& wounded all the reste, leavinge many of theim for Dead.'

Some eleven years later, Connaught was tried at Chester assizes for the murder of 'several persons', although much of the trial focused on the killing of John Fowler. Having been found guilty, Connaught was hanged at Boughton on the outskirts of Chester.

In the churchyard there are memorials of two local men, both of whom died of First World War: Edgar Ginders and his brother George Percy Ginders, both of whom were soldiers in the New Zealand Expeditionary Force.

Up until relatively recently St Bertoline's (Bartoline) was the only church in England dedicated to the eighth-century prince, who following the death of his wife spent the rest of his life living as a hermit. It is said that Bertoline performed a miracle on the site where the church now stands. The legend of St Bertoline's miracle maintains that, when challenged by the Devil to transform stone into bread, instead the saint opted to change bread into stone.

Location: CW2 5PF

2. St Mary's Church, Acton

There has been a church on this site at Acton (meaning 'Oak Town') since before the time of the Domesday survey. At the time of the survey, there was a church together with two priests at Acton. Combermere Abbey had been given the church and its lands by Hugh de Malbank, 2nd Baron of Wich Malbank, early in the twelfth century. At the time of the Dissolution of the Monasteries, the advowson was granted to Richard Wilbraham. From there it passed to the Lords Tollemache.

The nave has four bays, but the north and south aisles have six bays. There are three bays in the chancel with a vestry on its north side. The Mainwaring Chapel is at the east end of the north aisle. The Dorfold Chantry is at the north side of the tower. Twenty-eight members of the Wilbraham family lie beneath the raised floor of the Dorfold Chantry. Still remaining around the sides of the church is some of the old stone seating. There are also some ancient carved stones in the south aisle that date back to the Norman era. These stones are in two groups and

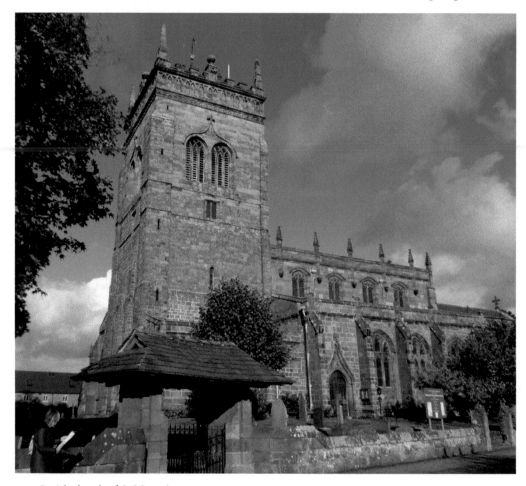

Parish church of St Mary, Acton.

are thought to have been carved by different sculptors. The style of the first group of stones, which are carved in limestone, would suggest that they were carved towards the end of the eleventh century. Previously, the limestone reliefs were set into the stone bench that ran around the church, although it is unlikely that this would have been their original location. The other group of stones are carved from red sandstone and were discovered embedded in the clerestory wall during the major restoration of 1897. The style would suggest that they were carved at the beginning of the twelfth century.

Like some of the other churches in the area, such as Bunbury, the tower rests upon three arches and the western wall – such towers are known as 'engaged' towers. The tower itself was built to a height of over 30 metres towards the end of the twelfth century and is the oldest tower in Cheshire. However, during a great storm on 15 March 1757 the top of the tower collapsed, causing damage to the clerestory and the roof of the church. The tower was eventually rebuilt, but, following advice, it was deemed that it should be rebuilt to a much lower height.

Over succeeding years many additions were made to the building; the north aisle was built towards the end of the fourteenth century, with the south aisle and chancel being built in the early fifteenth century. Much damage was done during

St Mary's from the south-east.

A sundial in church grounds.

the Civil War, resulting in restorations becoming necessary in the seventeenth and eighteenth centuries.

The whole church was completely restored between 1897 and 1898 under the direction of the Lancaster architects Austin and Paley. A new pulpit, porches and doors were added, and the north wall of the north aisle and the clerestory were rebuilt. The church was also re-floored and re-roofed at this time. Much of the restoration was funded by Mr E. Sutton Timmis in memory of his mother. The cost of renovating the organ chamber was met by Mr H. J. Tollemache of Dorfold Hall, and the repairs to the chancel were paid for by the patron.

There is the canopied wall tomb of Sir William Mainwaring, Lord of Baddiley and Peover in the Mainwaring Chapel. The effigy depicts a recumbent Sir William dressed as a knight in plate armour; his head rests on a helm bearing an ass's head and around his neck is a gold Collar of Esses – the SS stands for 'Sanctus Spiritus', which means the Holy Spirit. Sir William went to France on the king's business and died there in 1399.

There is a marble tomb commemorating Sir Richard Wilbraham, his son Sir Thomas Wilbraham, and both of their wives. The tomb is at the east end of the south aisle. Many of the stained-glass windows in the church, including the east window, are attributed to the Victorian stained-glass designer Charles Eamer Kempe. The Communion rail dates from 1685, as does the screen in the Dorfold Chapel. The Ten Commandments are shown on the reredos to the north of the altar, and to the south are the Creed and the Lord's Prayer.

The font of black basalt has a Norman bowl with lead lining set on a nineteenth-century base. It consists of a round bowl carved with figures and simple ornamentation. The font now stands just inside the main door of the church, signifying that baptism is the entrance into the Church. However, this was not always the case, as for many years it served as a pig trough in a local farm. The font was then removed to the terrace at Dorfold Hall where it remained for some time before being returned to its rightful place in 1897 by Mr H. J. Tollemache.

The first three bells at St Mary's were founded by Abraham Rudhall II in 1724 and taken by boat along the River Severn to Atcham Bridge before continuing their journey by horse and cart to the church. Another two bells were foundered by Thomas Rudhall in 1773. A sixth bell, cast at the foundry of John Taylor & Co. of Loughborough, was added in 1893. At that time all of the bells were retuned and rehung.

Alex Young and Sons of Manchester made the two-manual organ in 1897. The organ was renovated in 1939 and again in 1997.

The clock, which moves by a weight at the end of a rope running round an axle, is located in a chamber between the belfry and the bell chamber. The clock was installed by Peter Clare of Manchester in 1788.

There are war graves of five Commonwealth service personnel in the churchyard – two graves of personnel who gave their lives in the First World War and three graves of personnel who lost their lives in the Second World War.

Albert Neilson Hornby, who played cricket for Lancashire and England, is buried at St Mary's. He was the first of only two men to captain his country in both cricket and rugby.

The sandstone sundial in the churchyard is over 12 feet high. It was originally a medieval cross and was made into a sundial in the seventeenth century.

Location: CW5 8LE

3. St Laurence's Church, Frodsham

Reference is made in the Domesday Book to the fact that there was a church and a priest in this place. The abbot of St Werburgh's Abbey, Chester, was then given the tithes by Hugh Lupus in 1093. The tithes then passed to the monastery of Vale Royal when it was founded by Edward I in the late thirteenth century. Ultimately, following the Dissolution of the Monasteries, the dean and chapter of Christ Church, Oxford, were granted the tithes and advowson of the parish.

The church of St Laurence is built from local sandstone and dates from the late twelfth century. The tower was built in the fourteenth century when the chancel was first lengthened. The chancel was lengthened further in the following century. Both the north chapel and south chapel were added during the sixteenth century.

Under the direction of the Gothic Revival architects Bodley and Garner there was some reordering of the church between 1880 and 1883, which included removing the galleries and plaster ceilings.

The church has a nave of three and a half bays, a three-bay chancel with a sanctuary, a three-stage west end tower with a clock on the north and south faces, north and

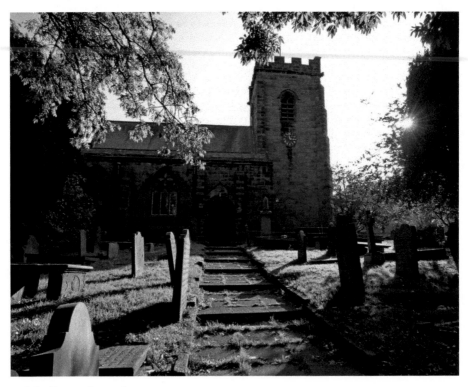

Path leading to the north entrance.

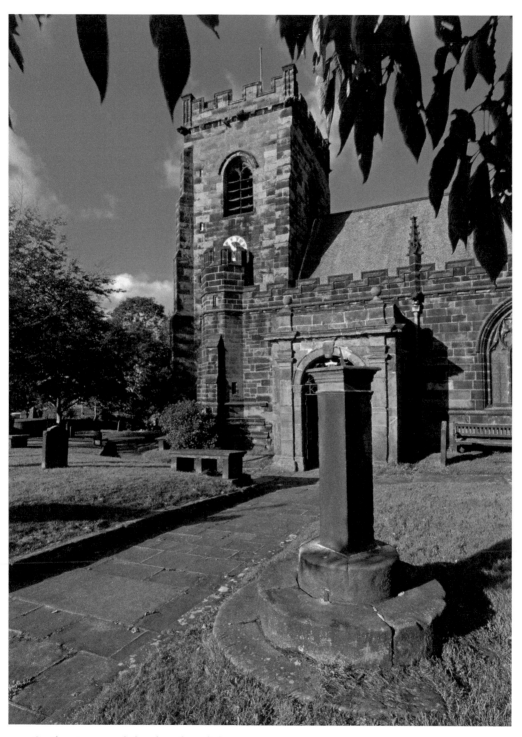

South entrance and churchyard sundial.

south aisles and north and south two-bay chapels. The south chapel, formerly known as the Kingsley Chapel, is now known as the Lady Chapel; the north chapel, formerly known as the Helsby Chapel, is now known as the Blessed Sacrament Chapel. The north porch was added in 1715 and the south porch was added in 1724.

There are some Saxon and Norman carved stones that have been reset in the south wall of the tower. The nave is a fine example of Norman architecture and, although the arcades have been restored, they still retain some Norman material. The altar rails date from the seventeenth century. The pulpit itself is Victorian and replaces a three-decker pulpit. The font dates from 1880 and is by the noted Gothic Revival architects Bodley and Garner. The organ was built by the Leeds organ builder James Jepson Binns between 1882 and 1883. The company then rebuilt the organ in 1923. In 1982, a further rebuild was carried out by George Sixsmith & Son Ltd of Ashton-Under-Lyne. The reredos in the north chapel dates from the beginning of the eighteenth century. A stained-glass window in the baptistery by Shrigley and Hunt depicts the Good Shepherd. There are also three windows by the ecclesiastical stained-glass maker Archibald Keightley Nicholson. Robert Harper made both the altar table (dated 1678) and the parish chest (dated 1679).

Although there have been many noteworthy and eminent vicars of Frodsham, there is one who has attracted less than fulsome praise, and that was Francis Gastrell A.M., who was presented by the dean and chapter of Christ Church on the death of the former vicar Thomas Roberts in 1740. Gastrell was vicar of Frodsham for thirty-two years, until he died in 1772. During his incumbency Gastrell gifted much of the church plate. And, being a wealthy man, he also purchased New Place, Stratford-upon-Avon, a house that was previously owned by Shakespeare. In the garden there was a famous mulberry tree, which Shakespeare himself had planted and which was visited by crowds of pilgrims. However, Gastrell found the constant stream of visitors tiresome and 'wantonly and ruthlessly' pulled down the poet's house and cut down the honoured tree.

Also during vicar Gastrell's time, a banner epitaph was put up in the church which stated: 'Near this place lies the body of Peter Banner, carpenter, who died of a dropsy, Oct. 21, 1749, aged 50. In 33 months he was tapped 58 times, and had 1032 quarts of water taken from him.'

Francis Gastrell and his wife, Jane, are both buried in the churchyard. There is a ring of eight bells, six of which were cast by Rudhall of Gloucester: (1) 'Peace and good neighbourhood, A. R., 1743;' (2) 'Prosperity to the Church of England, A. R., 1781;' (3) 'Prosperity to the Parish, A. R., 1734;' (4) 'We were all cast at Gloucester by A. Rudhall, 1734;' (5) 'W Knowles and Th. Lancaster, churchwardens, 1734;' (6) 'I to the church the living call, and to the grave do summons all, 1734.' The other two bells date from 1911 and were cast by John Taylor and Company.

There is a sundial in the churchyard dated 1790. The churchyard also has the war graves of fifteen Commonwealth service personnel from the First World War and six from the Second World War. The teenage son of King Jaja of Opobo, Nigeria, Prince Warabo, is also buried in the churchyard. He attended school in Frodsham, but died in 1882.

Location: WA6 7DU

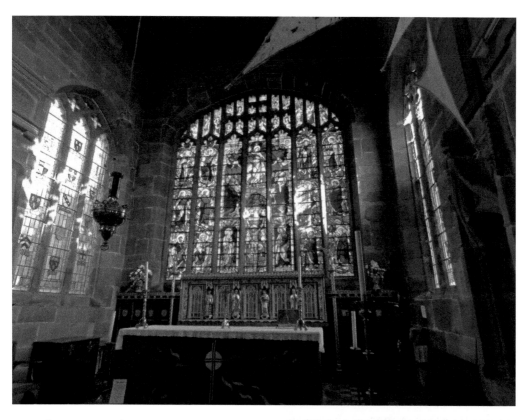

Above: East window.

Right: Font at the southern entrance.

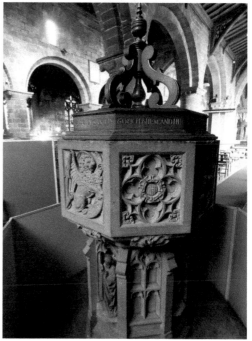

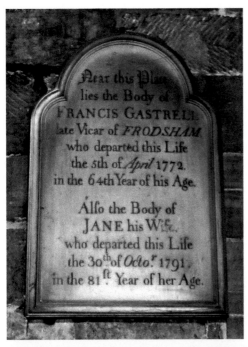

Near this Place
lies the Body of
FRANCIS GASTRELL
late Vicar of *FRODSHAM*
who departed this Life
the 5th of *April* 1772.
in the 64th Year of his Age.

Alſo the Body of
JANE his Wife.
who departed this Life
the 30th of *Octo.r* 1791.
in the 81ſt Year of her Age.

Left: Memorial to Francis Gastrell.

Below: Norman arches in the nave.

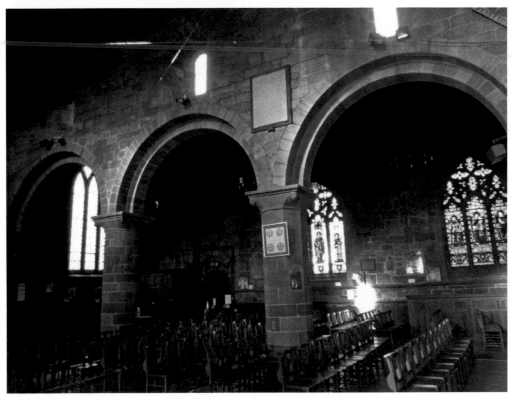

4. St Peter's Church, Plemstall

The recorded history of St Peter's Church, Plemstall, can be traced back to the seventh century. It is thought that the present church was built on the site where Plegmund, a ninth-century hermit who later became Archbishop of Canterbury, once lived.

The church stands in a raised area formerly known as 'the Isle of Chester'. The present church, which was financially supported by the Trafford family, dates from the fifteenth century, although the original church on this site was built sometime in the twelfth century. Over the years the church has undergone a number of restorations, including work carried out in 1684, 1711, between 1802 and 1803 and then later in 1819. As recently as 1958 the church had to be re-roofed due to an infestation of death watch beetle.

The church has a five-bay nave and a chancel in one range. There is also a sixteenth-century south porch and a north aisle with a chapel at the east end. The two-stage west-end tower was added in 1826 and has crocketed finials.

The Revd Joseph Hooker Toogood, who was the incumbent of St Peter's from 1907 until 1946, can take much of the credit for many of the refurbishments

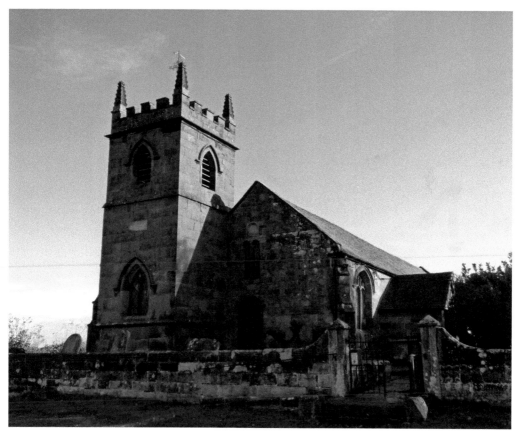

Parish church of St Peter, Plemstall.

carried out during that period. Toogood is credited with making the lectern, improving the baptistery, and refurnishing much of the north chapel. He also improved the chancel screen, made a new altar, together with the reredos and panelling for the sanctuary. Toogood also did some work on the choir stalls and carved a list of sidesmen on the west wall, together with a war memorial which is on the north wall.

Originally known as the Trafford Chapel (being the burial place of the Trafford family of Bridge Trafford), the chapel at the east end of the north aisle is now known as the Barnston Chapel. From 1403 to 1422 William de Trafford was vicar of the parish, and the lower part of the screen in the chapel was carved in his memory. The Elizabethan altar in the chapel was originally the main altar.

The three-decker pulpit is in the north aisle, and the adjacent two-decker reader's desk is dated 1722. The 7-foot-high churchwarden's pew dates from 1697. The Chester firm of Charles Whiteley made the organ, which dates from 1873. The organ was restored by David Wells of Liverpool in 2003. St Peter's has a ring of three bells, the first dating from 1635.

The church was presented with five Bibles in 1945 by the historian Raymond Richards. They include a folio edition of the Bible that was printed by Edward Whitchurche in 1549, a black letter Bible also of 1549, a 'Breeches' Bible dated 1608 and two King James Bibles, one dated 1611 and the other dated 1623.

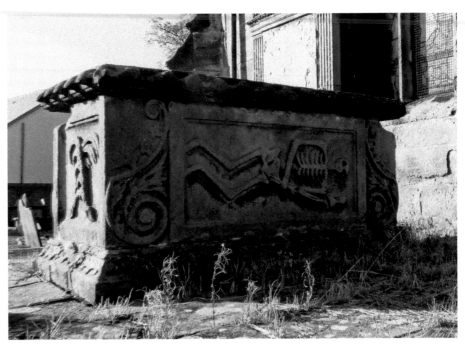

Recumbent male skeleton.

Box pews at Plemstall.

Above the large Hurleston family vault at the east end of the church there is a chest tomb. On its south- and north-facing sides there are the recumbent skeletons, apparently one male and the other female.

Dating from 1795 and standing by the chancel door in the churchyard, there is a pedestal cenotaph to the memory of Thomas Cawley and others. There is also baluster sundial in the churchyard dating from 1730.

Close to St Peter's Church is a well named after Plegmund, the ninth-century hermit who became Archbishop of Canterbury in 890 under Alfred the Great. Prior to becoming Archbishop of Canterbury, Plegmund lived as a hermit and is said to have baptised people who visited his cell at the well. However, many years before Plegmund, the well is thought to have been used by Druids.

Plegmund died on 2 August 923 at Canterbury, where he was buried. When he was canonised, the day of his death became his feast day.

Location: CH2 4EW

5. St Helen's Church, Northwich

The church was initially built in the vicinity known as Witton as a chapel of ease for St Mary and All Saints' Church at Great Budworth. Numerous additions were

made to the fourteenth-century church in the fifteenth, sixteenth and nineteenth centuries. The chapel of ease had similar dimensions as the present building, although there were no aisles, chapels or clerestory. The chapel did not have pews as such, but had stone benches strategically placed around the walls for the comfort of parishioners. With increases in population and church attendance, north and south aisles were added. Following the rebuilding of the aisles during the sixteenth century, one of the side chapels – now known as the Lady Chapel – was brought into the main body of the church. Sometime later the nave itself was made wider, with the chancel also being widened to complement the nave. Thomas Farmer, Master of Witton Grammar School, left a legacy in his will in order that the chancel could be embattled. The name 'Thomas Hunter' can be seen on the tower, which was built towards the end of the fifteenth century, and

West tower at St Helen's.

Sandstone sundial.

it is known that a mason of that name had been engaged on work in the nearby Norton Priory.

The church has a six-bay nave with north and south aisles, a chancel with a vestry to the north, a polygonal east apse and a four-stage tower. Sometime during the eighteenth century galleries were built on three sides of the church, although they have subsequently been removed. Towards the end of the century an organ gallery was placed over the chancel to house the organ, but this was later moved and placed in the west gallery.

Major restoration works were carried out in 1841, including the rebuilding of the south and west galleries, renovating the roof and repairing the west door. The pulpit was also re-sited during the renovations. However, just twenty years later the chancel had to be rebuilt as a large crack had appeared in the wall. It is a distinct possibility that, like the rest of the town, the church had fallen victim to the subsistence that was endemic at that time. Fortunately, being built at the top of a hill, the damage was less severe than had been experienced by many other buildings in the town. For a period of three years, between 1883 and 1886, Paley and Austin, the Lancaster architects, instigated further changes; the north aisle was widened, and a vestry and a baptistery were added. The church was also re-floored.

St Helen's has a rare seventeenth-century altar table. Of particular note in the church is the seventeenth-century carved beam which is in the vestry and the decorated reredos in the south chapel and the south aisle. The three-manual organ was built and installed between 1870 and 1880 by Alex Young and Sons of Manchester and later rebuilt by Charles A. Smethurst & Co., also of Manchester. The current clock was installed by the then vicar in 1888 as a memorial to his father, Hibbert Binney DD, Bishop of Nova Scotia. The clock, made by engineers W. H. Bailey of Salford, was refurbished in 1911.

There is a ring of eight bells at St Helen's. Originally, there were six bells, all cast by Richard Sanders of Bromsgrove – five being cast in 1712 and one in 1852. Then, in 1877, two more bells were cast and installed by the bellfounders John Taylor and Company of Loughborough. In 1910, all eight bells were taken down, recast and rehung by Taylor's.

During the period of the Reformation and the Civil War, the church lost many of its stained-glass windows and medieval monuments. Fortunately, between 1863 and 1910, leading stained-glass designers, including William Wailes, Charles Alexander Gibbs and the celebrated Victorian designer Charles Eamer Kempe, were commissioned to design and install new windows, which now adorn the church. Then, in 2000, the Millennium Window was designed by pupils from Church Walk School.

In the churchyard there are war graves of seven soldiers killed during the First World War and the war grave of a Royal Navy sailor who lost his life during the Second World War. Also in the churchyard is a sandstone sundial which was erected by the stonemason John Moors in 1800.

Location: CW9 5PB

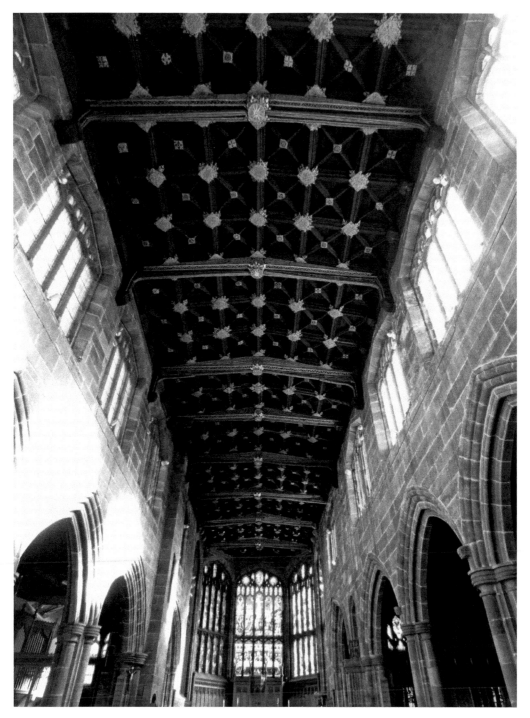

Camber beam ceiling.

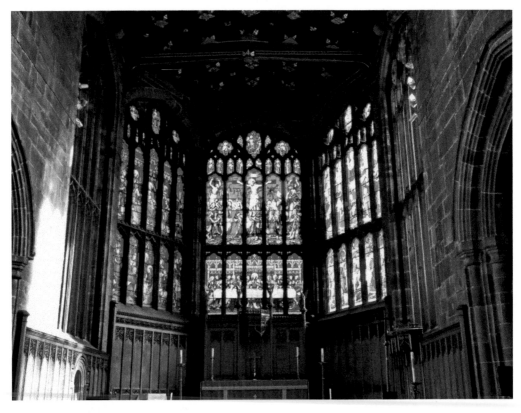

Above: East window.

Left: Lych gate.

Millennium Window.

6. ST PETER'S CHURCH, CONGLETON

As early as the fifteenth century, a church was built on this site, acting as a chapel
of ease for St Mary, Astbury. But by the mid-eighteenth century the timber-framed,
wattle-and-plaster church had decayed.

In 1705, galleries were added around the timber-framed chapel, but it still
proved to be too small for the size of the congregation. Successful representations
were made to the bishop, which enabled the chapel to be demolished and a larger
one built in 1740. The original fourteenth-century tower at the western end of

Parish church of St Peter, Congleton.

the church was retained, then raised in 1786 under the direction of the architect William Baker of Audlem. When the timber-framed chapel was being demolished many of the artefacts were also removed, but the fifteenth-century solid oak chest with iron bands was retained. The box contained many of the church's treasures, including vestments, plate, manuscripts and an amount of money to give to poor people living in the parish. Building the church took much longer than had been anticipated, and, because of spiralling costs, the galleries in the north and south-west corners were not built as scheduled.

The marble font at St Peter's dates from 1742, the reredos from 1743 and the brass candelabrum, which was presented by John Smith, was added in 1748. The chandelier included a dove with a twig in its beak returning to Noah's ark, symbolising God's promise that the flood would recede and all would be well again. The Apostles' Creed, the Lord's Prayer and the Ten Commandments are shown on the panels of the reredos. On the east wall there are paintings of St Peter and St Paul by the portrait painter Edward Penny of Knutsford. Peter is portrayed acknowledging his betrayal of Christ, whereas Paul is shown with a letter in his hand and sword by his feet.

Looking towards the west door and west window.

In 1742, the Georgians placed a three-decker pulpit in the centre of the aisle in the rebuilt chapel. The minister preached from the highest level, with worshippers in the gallery above only being able to see the minister during the preaching of the sermon. Also in 1742, the top semicircle of the east window incorporated coloured glass and depicted the Holy Spirit descending as a dove. Much later, in 1922, Mrs Ellison, widow of Revd James Ellison of St Georges Sutton, commissioned Walter Pearce of Manchester and Wilmslow, who was part of the Arts and Crafts movement, to design and install a stained-glass window as a memorial to her parents, Thomas and Martha Barrow. The five-panel window illustrates various scenes from the life of Jesus, with the large centre panel showing Jesus declaring, 'Because I live, ye shall live also'.

Preaching from the original pulpit in 1788, John Wesley addressed the leading gentlemen of the town, including the minister, mayor, and several aldermen. The text of his sermon that evening was, 'Thou shalt have no other Gods before me.'

Even when the new chapel had been finished its status was still that of a chapel of ease. In 1840, the corporation financed the building of the corner galleries, the recasting and rehanging of the bells and the enlarging of the tower, but the passing of the Municipal Corporations Act removed corporation's right to choose the minister. The new church became known as the parish church of St Peter.

The main body of the church is built in red brick and has some stone dressings, and the tower, built at a later date, is of stone. St Peter's has a five-bay nave and then a single-bay chancel. The church has both north and south aisles. The west end door has a porch with Doric columns.

There are a number of wall tablets, including a tablet in memory of a British army officer, Sir Thomas Reade. Sir Thomas was appointed consul general in Tunis in 1836, and the tablet depicts a native kneeling by a palm tree.

Between 1839 and 1840, Joshua Radford extended the church at the west end by one bay on each side of the tower. A west end porch was also added during the alterations.

The original pulpit was dismantled in 1877 and, in its place, a Jacobean pulpit was erected. More latterly, in 1985, that pulpit was removed and the surviving section of the original Georgian pulpit was reassembled in a slightly different form, enabling the pulpit to be moved, thus creating a degree of flexibility and allowing for different expressions of worship.

The organ was built in 1824 by Renn and Boston at a cost of £1,000. Much in need of repair, the organ was completely rebuilt in 1911 by Steele and Keay, organ builders in Burslem, utilising several stops and pipework from the original organ. When the rebuilding had been completed, the organ was dedicated to one of the church's earlier organists, Samuel Crowther Eyre, who had been the church organist for over fifty years.

St Peter's has a ring of eight bells, with the original bells dating from the reign of Elizabeth I, cast by Henry Oldfield of Nottingham. Early in the seventeenth century three of the bells were recast and a treble was added by the Congleton foundry of Paul Hutton.

In 1720, the bells were recast by Rudhalls of Gloucester, with the Articles of Agreement relating to the recasting being very specific. The five bells were to be transported to Gloucester by Rudhalls and, following recasting into six bells, they were to be returned to Congleton by Abraham Rudhall. The articles also specified that the new bells were to be the same weight as the five bells that had been returned, and that, should any additional metal be required in the recasting, then the extra cost would be borne by the mayor and corporation.

When the church had been rebuilt between 1740 and 1742, the tower of the old chapel was retained and the bells were hung there. A seventh bell was cast by Rudhalls in 1757 bearing the inscription, 'Prosperity to this parish. A.R.1757'.

In 1786, two further storeys were added to the tower and, in 1806, an eighth bell was cast by Thomas Mears and Sons of London. Then, in 1911, all eight bells were rehung by John Taylor of Loughborough. There was a complete overhaul of the bells, also conducted by Taylor's, in 1933.

Bells were rung to signify special events in the parish. Up until 1839 the tenor bell rang at ten o'clock each weekday night and at nine o'clock on Sunday, reminding innkeepers that it was time to close their hostelries. Another of the church's traditions was the ringing of the Pancake Bell. On Shrove Tuesday at eleven o'clock the Pancake Bell was rung, thus allowing boys from the local grammar school to be released for a half-day's holiday. The Pancake Bell has now ceased to be rung, but one tradition that was maintained until early in the twentieth century was the ringing of the Curfew Bell. Dating from 1068, the bell was rung every night at eight o'clock, except Saturday and Sunday, and obliged householders would extinguish hearth fires.

The war memorial, which is in the west porch, bears the names of eighty men who lost their lives in the First World War, most coming from the town itself and some coming from neighbouring towns and villages. The churchyard has the war graves of eleven British service personnel, seven being from the First World War and four being from the Second World War.

Location: CW12 4AB

7. ST CHRISTOPHER'S CHURCH, POTT SHRIGLEY

Founded in the late fourteenth century, the church was built as a chapel of ease for the parish of Prestbury. It is thought that members of the Downes family, who for five centuries had been the local squires, built the church. It took on its present form in the fifteenth century, when Geoffrey Downes, brother of the local squire, added the Downes Chantry Chapel. At that point the chapel of ease then became the parish church of St Christopher.

In the main, the church follows the Perpendicular style of architecture. The church has a short two-bay nave, a west tower, a chancel and wide north and south aisles. The tower, which is relatively large, has battlements, pinnacles and walls that are reputedly 4 feet thick. There is also a four-faced clock made by Thomas Schofield of Manchester, which dates from 1809. The nave and

 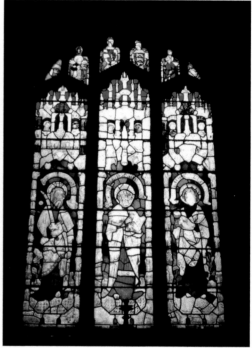

Above left: Parish church of St Christopher, Pott Shrigley.

Above right: East window.

chancel still retain their original plaster on a reed backing fifteenth-century barrel roofs.

When St James' Church, Gawsworth, was restored during the nineteenth century, some of the oak box pews were removed and taken to St Christopher's. There is a holy table in the north aisle, which dates from 1695. Also dating from the late seventeenth century are two sanctuary chairs. The Downes and Lowther families are commemorated in a number of memorials in the church. Dating from the late eighteenth century, the font is of grey marble. The east window, which still retains much of its original glass, was restored in 1872 by Clayton and Bell of London.

St Christopher's has a ring of six bells. Originally there was ring of three bells cast by Robert Crouch and dating from around 1430. In 1607, the tenor was recast by Henry Oldfield II of Birmingham. Following local fundraising in the 1980s, three more bells were added in 1986, cast by Royal Eijsbouts – the Dutch bellfounders.

There is ancient preaching cross in the churchyard, which stands on two large, medieval square blocks. The cross was repaired sometime in either the late eighteenth or early nineteenth century, which is in all probability when the tall octagonal shaft and cross piece were added.

Location: SK10 5RT

Above left: The eighteenth-century grey marble font.

Above right: The ancient preaching cross at St Christopher's.

Right: The lych gate war memorial.

8. St Wilfrid's Church, Grappenhall

When the hamlet of Grappenhall was originally mentioned in the Domesday Book of 1086, there were only six adult male inhabitants. The first church on the site was likely built in the early part of the twelfth century. This was verified during the church restoration of 1873/74, when the earlier foundations were uncovered directly under the present nave and chancel. At that time, the earlier church consisted of a nave and chancel and, possibly, an apse.

There is a plaque inside the church, which gives a continuous record of all the rectors of Grappenhall, starting with Robert of Gropenhale, who witnessed the charter in 1189.

The Boydell family added a chantry chapel in 1334. Major restoration and refurbishment were started in 1529 when the old church was demolished and a new chancel, nave, north aisle and tower were built. Ten years later the south aisle was added, incorporating the Boydell Chapel.

St Wilfrid's parish church.

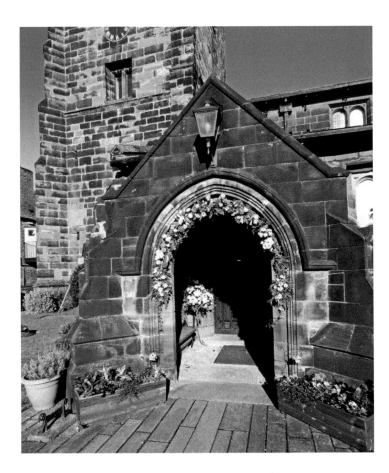

South entrance to
St Wilfid's.

In 1641, the south porch was added. Further work was carried out in the
nineteenth century, when the roof of the nave was raised and, later, the south aisle
was extended and a vestry was built. However, further major restoration work
was carried out between 1873 and 1874 under the direction of the Lancaster
architects Paley and Austin, when floors were re-laid and roofs re-tiled.

St Wilfrid's Church, Grappenhall, follows a traditional plan, having a
continuous nave and chancel of seven bays with a clerestory together with north
and south aisles. The local red sandstone from which the church was built was
from Cobb's quarry. There is a chapel at the east end of the south aisle, a vestry and
a south porch. There is a three-stage tower with a Tudor west door. The chancel
east window follows the Perpendicular style of architecture. There is also on the
wall of the south aisle a remnant of a Norman corbel table, which is decorated
with carved human heads.

There is a memorial to the Drinkwater family of Thelwall which dates from 1624.
There is also a holy table, which dates from 1641, inside the church. The carved oak
reredos depicts the painting of *The Last Supper* by Leonardo da Vinci. There is an effigy
of Sir William Boydell in the chancel. Initially this was to be found in the churchyard,
but was restored and brought into the church in 1874.

Above: Carved high in the church wall is the original Cheshire cat.

Left: Sundial in the churchyard.

When St Wilfrid's was being restored in the late nineteenth century the Norman font, one of the treasured artefacts of the church, was rediscovered in March 1873. The font had been buried during the Reformation in order to save it from destruction. The church was also re-pewed during the restoration work.

One of the windows in the south aisle contains some fourteenth-century glass. The glass, which was rearranged during the nineteenth century, depicts seven saints. Meyer of Munich manufactured the other windows in the aisle.

There is a new ring of ten bells at St Wilfrid's. The bells, all of which were donated by individuals or groups within the parish, arrived at St Wilfrid's in July 2019. The bells were cast at the foundry of John Taylor & Co. of Loughborough. Four of the old bells have been preserved and now hang above the new bells in the tower. The history of the bells goes back over 300 years, with the first bells dating from 1700. The original five bells in the tower were cast at the foundry of Henry Bagley II at Ecton, Northamptonshire. In 1718, a smaller, treble bell was cast by Sanders of Bromsgrove, making a ring of six bells. The small treble bell was recast in 1890 and a new bell frame installed by John Taylor & Co. of Loughborough.

A further two bells were added in 1899, making a ring of eight bells. The new bells were cast at the Whitechapel Bell Foundry of Mears and Stainbank. Also at that time the old fourth bell, which had been cast by Henry Bagley, was recast and became the fifth bell. The bell frame was strengthened in 1929 by John Taylor & Co. Then, in 1966, there was a major rehang, when new fittings were provided for all of the bells.

Just below the west window on the outside of the church there is a relief sculpture of a 'Cheshire cat'. It is believed by many people that this was the inspiration for the cat in Lewis Carroll's stories – his father being the vicar of the nearby church at Daresbury.

The churchyard also has a sundial that dates from 1714 and, at the entrance to the churchyard, a set of stocks. There are five war graves of British service personnel, two dating from the First World War and three from the Second World War.

Location: WA4 3EP

9. St Mary and All Saints' Church, Great Budworth

It is recorded that there was a priest in Great Budworth at the time of the Domesday survey, but there is no reference made to there being a church in the locality. However, in 1130, William Fitz Nigel, Constable of Chester and Baron of Halton, granted permission for the Augustinian canons from the nearby Norton Priory at Runcorn to build a church in the area. The church of St Mary and All Saints was constructed of warm red sandstone and built during the fourteenth century.

The noted Cheshire historian Sir Peter Leycester suggested that the name 'Great Budworth' is derived from the old Saxon words *bode*, meaning 'dwelling', and *wurth*, meaning 'a place by water'.

The church is predominantly Perpendicular in style, although the north transept follows the Decorated style of architecture. In plan, the church has a six-bay nave with a clerestory and a chancel flanked by chapels to the north and south.

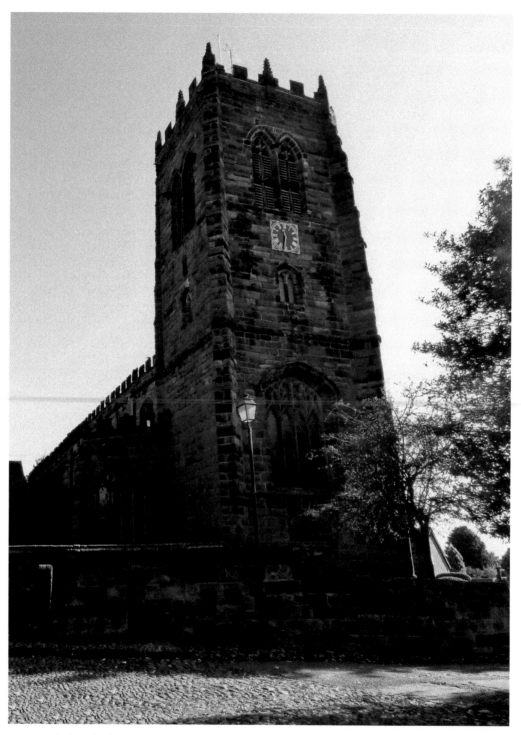

Parish church of St Mary and All Saints.

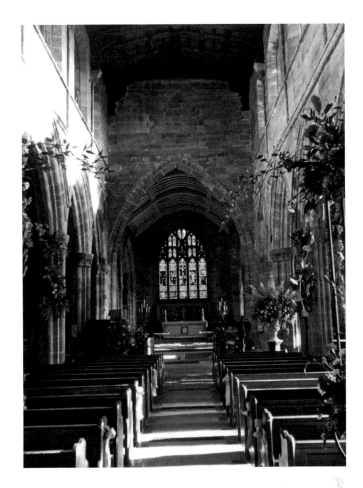

Looking towards
the chancel and east
window.

The north transept, which follows the Decorated Gothic style of architecture, is the Lady Chapel and is the oldest part of the church, dating from the fourteenth century; the south transept is known as the Warburton Chapel. There are north and south aisles, with the south door being located at the west end of the south aisle. The nave ceiling is subdivided into seventy-two panels and dates from the early part of the sixteenth century. It is known that the tower was built at the start of the sixteenth century by Thomas Hunter and bears the arms of the priory at Runcorn together with the arms of the Dutton and Warburton families. There is a sculpture of St Christopher on the north side, and on the south side is a sculpture of the Blessed Virgin. The tower has a clock on the west face; the top is crenellated with eight crocketed pinnacles. An early benefactor of the church was Geoffrey de Dutton, as were the Booths of Twemlow.

There are burial vaults for the lords of Tabley House and Marbury Hall under the floor of the Lady Chapel. Previously, during the medieval period, there was a statue of the Virgin Mary in the Lady Chapel, but this was destroyed on the orders of Elizabeth I. One of Cheshire's greatest historians and an antiquarian, Sir Peter Leycester, lies in the Lady Chapel. The architect Anthony Salvin designed the

screen in the Lady Chapel. Also in the chapel is an 'Organ of Historic Importance', which was designed by Samuel Renn and installed in 1839. The organ was restored by Alexander Young in 1886 and again by Jardine Church Organs of Old Trafford, Manchester, in 1918 and 1959. In 2004, the organ was restored by Goetze and Gwynn.

There are five thirteenth-century oak stalls in the Warburton Chapel, together with a number of the original plain misericords. There is also a stone altar in the chapel, which originally was in the chancel. At the time of the Reformation the stone was removed for safekeeping and was used as a flooring slab. When the altar was rediscovered in the nineteenth century it was placed in the Warburton Chapel. There is a large medieval oak chest in the church which has four locks. The four different keys to the locks were held by church officials and the chest could only be opened when all four keys were used. There is an alabaster effigy of Sir John Warburton in the chapel, which shows Sir John in exquisitely ornamented armour with a decorated sword belt and a lace collar. Across the entrance to the Warburton Chapel there is a heavy oak beam. Formerly, the beam was part of the nave, but when it was replaced the beam was used as a roof timber in a nearby farm. Ultimately, the beam was restored to the church and located in its current position.

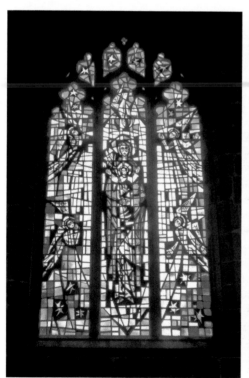

Above left: Glass in the north transept designed by Francois Pierre Fourmaintraux.

Above right: Looking towards the Warburton Chapel.

During the Reformation in the sixteenth century all involvement with the priory ceased and the previously highly decorated church that the Augustinian canons had created became little more than a whitewashed preaching hall. Puritan ministers then set about converting the people of the parish from a tradition of religious conservatism to a form of radical Protestantism. Ultimately, however, parishioners mellowed and accepted the broader Anglican Church traditions. Rowland E. Egerton-Warburton of Arley Hall funded much of the church restoration during the nineteenth century, and encouraged the return of a more Anglo-Catholic style of worship.

Together with many different carvings on the pillars is this one of a man 'pulling tongues'.

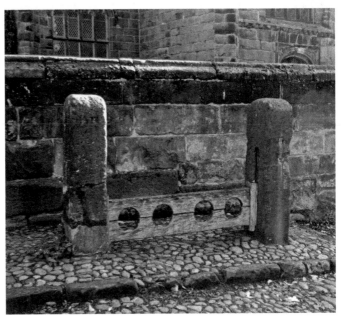

Village stocks outside of the parish church.

The fifteenth-century octagonal font was buried under the church floor during the time of the Civil War for reasons of security. During the restoration of the nave in 1868 the font was recovered and returned to its rightful place in the church.

The Victorian designer Charles Eamer Kempe designed the stained glass in the east window and also the east windows of both aisles. The French stained-glass designer Francois Pierre Fourmaintraux designed the Expressionist glass in the north transept.

It is recorded that in 1733 the bellfounders Abraham Rudhall of Gloucester installed a ring of eight bells in the tower at St Mary and All Saints' Church; subsequently, two of the bells were recast in 1760 and 1822 respectively. In 1922, the bellfounders John Taylor's of Loughborough retuned and rehung the whole ring. In 1996, local ringers father and son John and Gordon Birks, in conjunction with the bell-hangers Hayward Mills Associates, lowered the bells from high in the tower and installed them in the former ringing room.

The oak-framed lych gate to the churchyard was erected as a war memorial to the First World War in 1920. There is an oak crucifix on the front gable. There is also an eighteenth-century stone sundial in the churchyard, and the old village stocks, which also date from the eighteenth century, are just outside. Also in the churchyard are war graves of four British servicemen from the First World War and two war graves of British servicemen dating from the Second World War.

Location: CW9 6HF

10. St Andrew's Chruch, Tarvin

The parish church of St Andrew, Tarvin, has been built and added to over a number of centuries, with the first church on the site having been built in the twelfth century. The church was later remodelled during the fourteenth century when the south wall and south arcade were added. There was further rebuilding during the fifteenth century when the church tower was replaced. Also at that time, the clockmakers James Joyce of Whitchurch installed a clock on three faces of the tower. The other face was added ten years later in 1897 to mark Queen Victoria's diamond jubilee. During the eighteenth century the chancel was refurbished. Further structural work continued during the eighteenth and nineteenth centuries, with more work being carried out under the direction of the architect Frank Page Oakley during the early part of the twentieth century.

In plan, the church has a five-bay nave and a two-bay chancel. During the Civil War, when Cromwell's Ironsides had possession of the church, a bullet was imbedded in an old brass on the north chancel wall. The north aisle, built in the sixteenth century, has the Bruen chapel at its east end. In 1959, the ceiling was replaced by a Tarvin firm. The south aisle has the south porch. The tower doorway is in the Tudor style. The top of the tower is embattled and has the remains of the former pinnacles at the corners.

The original box pews were removed in 1875 when some restoration was completed and the present pews were installed. The choir pews were also installed at this time. The reredos, which dates from the beginning of the sixteenth century, is thought to be Flemish and came from a holy temple in Spain. It was a gift to the church from a former vicar.

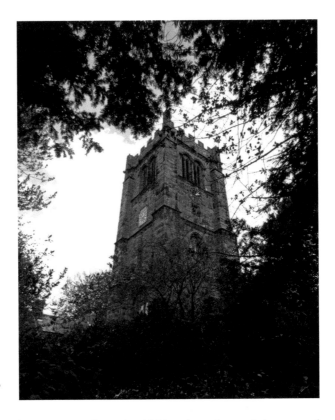

Parish church of St Andrew,
Tarvin.

Further restoration work was carried out in 1891, when the arch-brace and
hammerbeam nave roof was once again uncovered, after having been covered in
lath and plaster sometime in the eighteenth century.

The church's octagonal font dates from the mid-fifteenth century, but an
inscription on the inside of the bowl shows a date of 1330, although this date is
considered to be incorrect.

A two-tiered brass candelabrum, which dates from the eighteenth century and
is thought to have been made in Birmingham, can still be seen in the church. The
east window is attributed to Charles Eamer Kempe, and the more recent west
window was commissioned in 2006 by a parishioner in memory of her husband.
The window was designed by her daughter and further developed by Pendle
Stained Glass Ltd.

On the south wall of the Bruen Chapel is a 'squint' with a carved image peeping
through, referred to as the 'church imp'. The chapel has a memorial to John Bruen,
although it was John Bruen himself who ordered that all of the pre-Reformation
glass should be removed from the chapel because he considered it to form
'superstitious images and idolatrous pictures'. He also destroyed several stone
crosses in the area, including the Tarvin Cross in 1613.

St Andrew's has a ring of six bells; all were cast in 1779 at the famous foundry of
Thomas Rudhall of Gloucester. One tradition that was observed up until relatively
recently was the ringing of the 'Pancake Bell'. This tradition was observed every

Above left: The west door.

Above right: Sundial in the church grounds.

Shrove Tuesday at eleven o'clock, and was rung 'to remind housewives to mix their batter for their pancakes'.

An inspection in 2016 revealed that some renovation was required with regards to the bells. Funds were pledged by individuals and some organised groups, and a band of ringers from Cheshire raised £1,845 following a peal that lasted for two and a half hours. Having raised the necessary funds, the restoration work was carried out by Taylor's Foundry in Loughborough.

In 1874, St Andrew's had two organs; one was located in the Bruen Chapel, whereas the other was outside the screen of the chapel. This organ was moved in 1901 near to the stained-glass window of the north aisle. The ultimate aim was for a new organ to be installed, but paucity of funds prevented this, resulting in a decision to have the organ completely overhauled and refurbished. The work was carried out by Nicholson and Ward of Walsall. Further restoration work was carried out in 1973 by the Chester firm of Charles Whiteley and Company, when the hand-pumped organ was fitted with an electrically operated pumping system.

There is an eighteenth-century sundial in the churchyard and a number of tomb chests. There are war graves of three British soldiers, and the war grave of a Canadian soldier who died in the First World War.

Location: CH3 8EB

11. ST OSWALD'S CHURCH, LOWER PEOVER

It was in 1269 that Richard Gosvenor of Hulme Hall founded St Oswald's Church as a Chapel of ease, thus saving the long journey to the mother church of St Mary and All Saints' Church at Great Budworth. The site of the church was possibly chosen because of its proximity to an ancient burial ground – Barrows Brow. The church is dedicated to St Oswald, who was king of Northumbria and a converted Christian. As the king's remains were being taken from Oswestry to Lindisfarne it is thought that party might have stayed over at Peover, and that this might have influenced the dedication.

When the church was first built the priest from Great Budworth officiated at services, as there was no regular priest at St Oswald's. The first resident priest was installed during the fifteenth century and lived where the 'The Bells of Peover' now stands. The original timber-framed church would have had wattle-and-daub walls and a thatched roof, and worshipers would have stood or sat on the floor during the services, with older parishioners leaning against the walls for support. This tradition gave rise to the expression, 'the weakest go to the wall'.

A chantry chapel was added in 1464 by Robert Grosvenor, which was subsequently demolished on the orders of Henry VIII at the time of the Dissolution of the Monasteries.

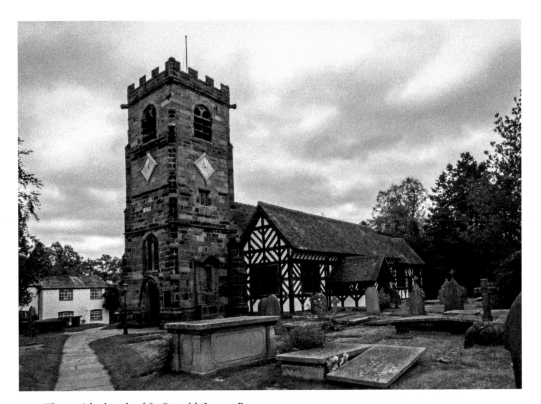

The parish church of St Oswald, Lower Peover.

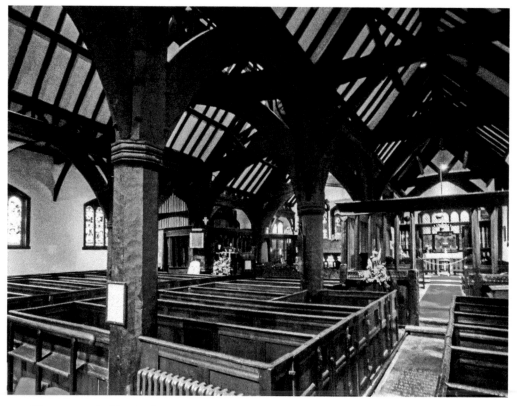

The octagonal pillars in the nave.

John Bowden was, reputedly, the mason who directed the building of the original tower in 1582. Two chapels, a south chapel and a north chapel, were added in 1610 and 1624 respectively. There was some major rebuilding at St Oswald's in 1851 which was carried out under the direction of the noted architect Anthony Salvin. The alterations included replacing the single broad roof by three gables, and the half-timbering was continued on all sides. Part of Salvin's plan also included removing the musicians' gallery at the back of the church.

The body of the church is timber framed and has a chancel, nave and west tower, together with chapels at the east ends of both the north and south aisles. The three-stage tower has a west door with a two-light window above. There are clock faces on three sides of the tower – north, west and south.

The Shakerley Chapel is at the east end of the south chapel, which is known as the Hulme or Grosvenor Chapel. There is an arcade of medieval octagonal oak piers which separate the aisles from the nave. The carved pulpit, a goodly number of the pews and the screen to the south chapel are Jacobean. The screen to the Holford Chapel dates from the seventeenth century, as does the screen separating the chapel from the nave. In 1322, the church acquired a disused cylindrical font from the nearby Norton Priory.

The carved seventeenth-century pulpit.

Located in the Shakerley Chapel in the south aisle is St Oswald's famous 'bog-oak, dug-out chest', made from a single log, measuring 6 feet long by tw2o feet wide. The chest was used for many years to keep parish registers, vicars' robes, chalices and other church documents. Before any service could commence, however, the four churchwardens and the minister had to be present so that all of the five locks, four of which had been added at the time of the Reformation, could be opened. For many generations there was a belief in the parish that if a maiden wished to marry a farmer then she had to be able to lift the chest lid with one arm. It is thought that this view emerged as, in medieval times, farmer's wives had to be strong enough to be able to lift one of the very heavy rounds of Cheshire cheese, which were made in most of the district's farms.

There are two bread shelves near to the font. From these shelves loaves of bread were distributed to the poor within the parish in accordance with a bequest made by Richard Comberbach and his wife.

Throughout the church there are a number of memorials to the Shakerley, Leicester and Cholmondeley families.

In 1880, Alexander Young of Manchester built and installed a two-manual organ, which was subsequently overhauled by G. Sixsmith and Son in 1985. The organ was completely rebuilt in 2015. The north chapel, known as the Holford Chapel, is now the organ chamber and vestry. The chapel was built by Sir Hugh

Left: Bread shelves at St Oswald's.

Below: The 'bog-oak, dug-out chest'.

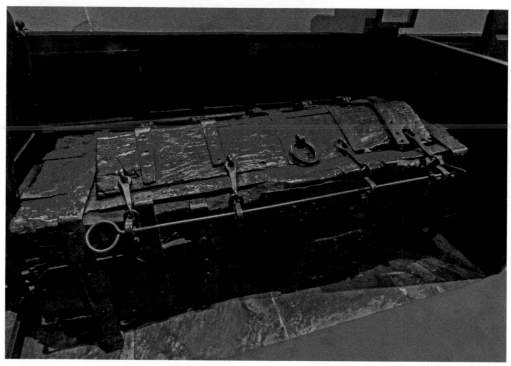

Cholmondeley and his wife, Mary Holford, in 1624. The original two bells had been augmented to four bells by 1625. There are now six bells in the tower.

Following his time at Cambridge, Richard Comberbach became the curate of St Oswald's Church in 1687. However, being a staunch supporter of the Royalist Stuart monarchy, he was forced to resign his position following the revolution of 1688. Remaining in the village as a farmer but wishing to pursue his ambition

of opening a school in the village, he purchased a plot of land in the south-west corner of the churchyard with the assistance of his wife, Margaret. The school was opened in 1710, with Richard and Margaret being the first teachers. Mr John Mear was appointed as the first master of the school, where he worked for many years. He is buried in the churchyard. Provision was made in Richard Comberbach's will for the provision and maintenance of a school teacher, or teachers, to teach the children of the poor within the Parish of Lower Peover. The will also made provision for classroom materials and repairs to the school building.

There is an eighteenth-century sundial in the churchyard. The lych gate dates from 1896 and was built during the incumbency of Revd Arthur Guest.

Location: WA16 9PY

12. St Wilfrid's Church, Mobberley

In the Domesday Book the village of Mobberley is recorded as 'Motburlege', but there is no reference to there being a church in the area. The first reference to there being any religious foundation comes in 1206, when a priory of regular canons of the Order of St Augustine was founded by Patrick de Mobberley, although it is known that there was a church here before the time of the Norman Conquest. The priory survived until 1240 when it was annexed by the priory of Rochester in Staffordshire.

Originally the church, which was built around 1245, was dedicated to St Wilfrid and St Mary, but in later years the sole dedication was to the Saxon St Wilfrid, Archbishop of York, who died in AD 708.

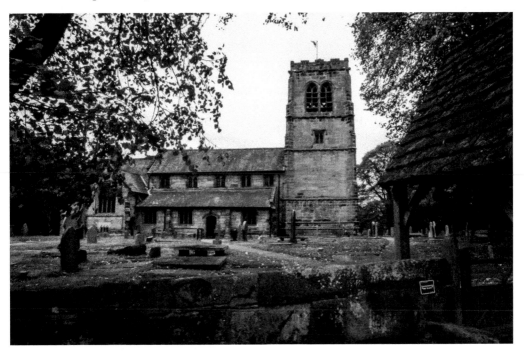

Parish church of St Wilfrid's, Mobberley.

West door at St Wilfrid's.

In its original 1245 form the church had a four-bay nave, a south porch and a chancel with a vestry to the north and narrow side aisles, the east end of the nave being the oldest part of the building. The church also had a detached four-stage tower. A new roof and clerestory were added and the north and south aisles widened in 1450. As the old tower fell into disrepair, a new one was built by John Talbot in 1533.

The church's ornately carved rood screen, made by Peter Alton, dates from the beginning of the sixteenth century and has several coats of arms and a number of other motifs, including that of the Green Man.

There is a strange painted board in the church that shows a dead body laid out in a shroud. The inscription is in memory of Elizabeth, wife of Nathaniel Robinson, who died 1665.

The piscina in the chancel dates from the thirteenth century. The armorial motifs of a number of the leading local families can also be seen in some of the fourteenth-century stained glass on the south side of the sanctuary of the church. The figure of St Christopher is depicted in a wall painting over the nave arcades and, similarly, there is medieval mural on the northern wall of the church that depicts St George slaying a recumbent dragon.

There was a major reordering of the church in 1888 when, under the direction of the architect Joseph Stretch Crowther, the chancel and vestry were rebuilt. Also, the tympanum above the choir screen was replaced by the chancel arch. The remains of a Saxon church were uncovered during this reordering.

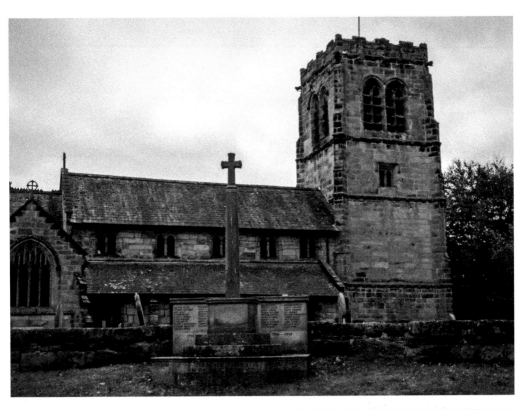

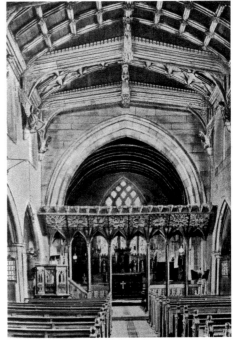

Above: War memorial at St Wilfrid's.

Right: An early photograph of St Wilfrid's Church.

The Mallory family had a long association with St Wilfrid's Church, Mobberley, and there are a number of windows and memorial plaques dedicated to the family throughout. After buying St Wilfrid's patronage in 1619, Thomas Mallory, Dean of Chester, took up residence in the manor house in 1625. Five members of the Mallory family then followed him as rector, the last being Revd Herbert Leigh-Mallory, father of Sir Trafford Leigh-Mallory and his brother, George Leigh-Mallory. Sir Trafford was commander-in-chief of RAF Fighter Command in the Second World War, and George Mallory who, with Andrew Irvine, lost his life while attempting to be the first climbers to scale the world's highest mountain, Mount Everest, in June 1924. The ecclesiastical stained-glass maker Archibald Keightley Nicholson was commissioned to design a memorial window. The window, which is perhaps the most poignant window in the church and certainly one of the best examples of modern stained glass in the county, depicts, from left to right, the three mythical figures of King Arthur, St George and Sir Galahad; Mallory was sometimes referred to as Sir Galahad. Also in the lower window there are two figures lifting their eyes to the white peaks of the Himalayas.

At one time, the organ, which was moved from the Manchester Free Trade Hall, was the property of Sir Charles Hallé. This organ was replaced in the 1950s by another pipe organ, which was itself replaced by the Phoenix organ present today.

The church has a ring of six bells, four being cast in 1772 by Thomas Rudhall and the other two by John Taylor and Company in 1891. All of the bells are marked with suitable inscriptions. The sixth bell, for instance, declares: 'I to the church the living call, and to the grave do summon all – Ring out clearer than before, God's praises evermore.' The ringer gallery at the west end of the church has a Jacobean carved rail dedicated to John Baguley and Henry Burges who were churchwardens in 1693.

In the graveyard there is the war grave of a soldier who died during the First World War and another of a soldier who died during the Second World War. There is a 'scratch' sundial to the right of the south door and, also by the south door, there is a thirteenth-century 'Consecration' cross cut in the stonework.

Location: WA16 7RA

13. St Oswald's Church, Malpas

A church is mentioned here in the Domesday Book, although the resident priest would have ministered from the timber-framed building that occupied the site until the present church was built.

Inside, there is a fragment of a Saxon preaching cross dating from 950. There is a stone doorway that was inserted in around 1150. A stone chancel, which incorporates Saxon stones, was added to the east in the middle of the next century. The original tower was built to the west of the church, but this was taken down and a new tower built to the north as a separate structure. The lofty nave of the church has side aisles, although the chancel itself, of lower elevation, does not have side aisles.

Many modifications and alterations were made during the following centuries, culminating in 1862 in the complete restoration of the interior under the direction of Sir George Gilbert Scott.

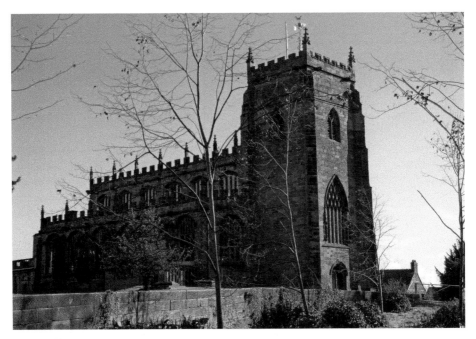

Parish church of St Oswald, Malpas.

Looking along the nave towards the altar.

The parish church of St Oswald, Malpas, with its unique trapezoidal plan and a five-bay west front, was built during the latter part of the fourteenth century. The church was rebuilt towards the end of the fifteenth century. Further restoration work was carried out in 1886 under the direction of Chester architect John Douglas. At this time the box pews were removed, as was much of the internal plaster.

The 70-foot-high tower dates from the fourteenth century and has a south-east octagonal turret. The porch at the south-west corner leads into the six-bay nave, which has north and south aisles. There are chantry chapels at the eastern end of each aisle. The south chapel originally belonged to the Brereton family, whereas the north chapel belonged to the Cholmondeley family. There is a three-bay chancel to the east of the nave. The vestry in the north-east corner dates from 1717. There is a parvis above the south porch and a wall sundial above the doorway.

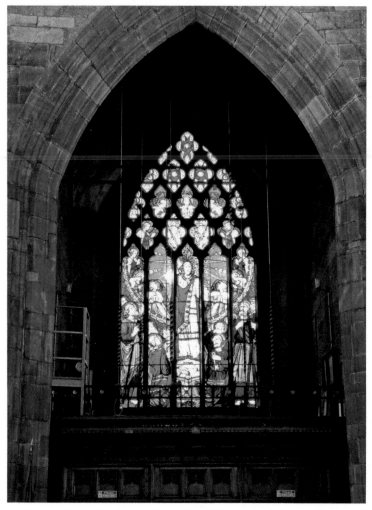

The five-light west window.

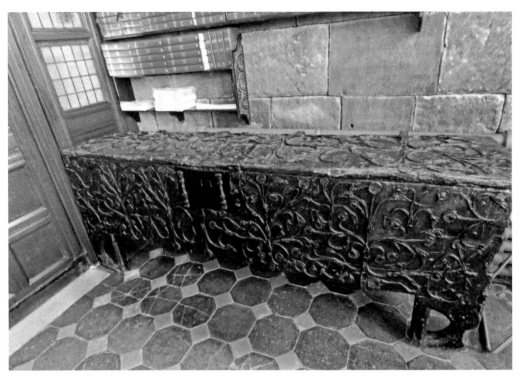

The ancient parish chest.

There is an oak chest dating from the thirteenth century in the nave. The octagonal font dates from the fifteenth century. A number of the original box pews from the Brereton Chapel are now at the back of the south aisle, but most of the other pews date from the late nineteenth century.

There is a painting of St Peter's denial of Christ by Francis Hayman above the chancel arch, and three pairs of hatchments belonging to the Dod family of Edge Hall, the Cholmondeley family of Cholmondeley Castle and the Tarleton family, formerly of Bolesworth. The tomb of Sir Randal Brereton and his wife is in the Brereton Chapel, which is dated 1522. In the Cholmondeley Chapel there is a monument to Sir Hugh Cholmondeley and his second wife, Mary. The chapel also has a memorial to Lady Cholmondeley who died in 1815. There is a memorial tablet to Charles Wolley Dod in the chancel.

The 'Presentation in the Temple' is depicted in a stained-glass panel in the north chapel and dates from the beginning of the sixteenth century. The English medieval revivalist William Warrington designed the east window of 1841 and the east windows in the aisles, which date from the same period. The window in the south aisle, dated 1902, is by the Victorian designer Charles Eamer Kempe. The window in the north aisle, which dates from 1928, is attributed to the Edinburgh-based James Ballantine. The east window is dedicated to the memory of Bishop Reginald Heber, the hymn writer, who was born in the town. In 1721, Mr Drake presented the altarpiece to the church.

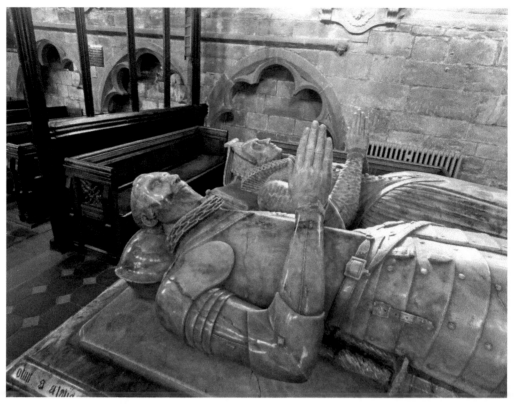

The seventeenth-century Cholmondeley tomb.

There are three fifteenth-century stalls and misericords against the south wall of the chancel. There is also a triple sedilia and a piscina on the south side of the chancel. A staircase leads from the sanctuary down to a vaulted crypt below the altar.

Lewis and Company built the two-manual organ in 1897. The organ was overhauled in 1962 by Rushworth and Dreaper of Liverpool. It was later restored by the Leicestershire-based Peter Collins.

St Oswald's has a peal of eight bells, although at the time of the first reference to the bells in 1522 at the funeral of Randle Brereton III, there were just five bells. In 1802, the churchwardens had the bells recast by John Rudhall, bellfounder of Gloucester. Then, with more metal being added, the peal of five became a peal of six. There was some further recasting in 1904 when Taylor's of Loughborough recast the tenor. Bell 5 was also recast as a memorial to Revd C. Wolley Dodd. In 1914, two more bells were installed by Taylor's, in memory of George and Anne Lewis.

There are church registers dating from 1561; however, one of the most interesting entries occurs in 1625, when it was recorded:

> Richard Dawson of Bradley, being sick of the plague, and perceiving that he
> must die, at that time arose out of his bed, and made his grave, and caused his

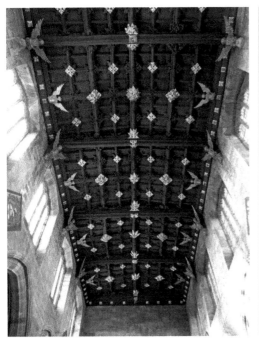 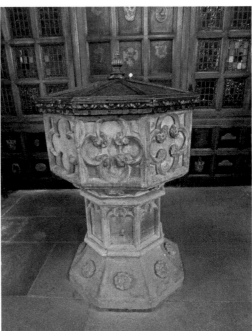

Above left: The medieval painted and gilded ceiling.

Above right: The fifteenth-century octagonal font.

nefew to cart straw unto the grave, which (again) was not far from the house, and went and laid him down in the said grave, and caused cloths to be laid uppon, and so departed out of this world. This he did because he was a strong man, and heavier than his said nefew and another wench were able to bury. He died about the 24th of August. This much he did.

In the churchyard there is a table tomb dedicated to members of the Duncall family. The tomb of John Bassett is also to be found in the churchyard, together with a sandstone sundial pedestal which dates from the eighteenth century.

Location: SY14 8NU

14. St Mary's Church, Nether Alderley

Alderley is referred to as 'Aldredeli' in the Domesday Book, but by 1327 it was known as 'Alderlegh'. The church dates from the early part of the fourteenth century, although it is probable that there was an earlier timber-framed church on the site before that time.

The church was originally dedicated to St Lawrence, but the dedication was later changed to St Mary.

The sandstone used for the construction of St Mary's was quarried at Alderley Edge. The church has a four-bay nave with north and south aisles. The chancel

has a vestry to its north and a south porch. A series of grooves can still be seen in the porch, where arrows were once sharpened. The embattled tower at the west end was built in the early sixteenth century. The church has a barrel-shaped nave roof which dates from the early sixteenth century. The tower clock, which was originally added in 1743, had a major overhaul in 1997.

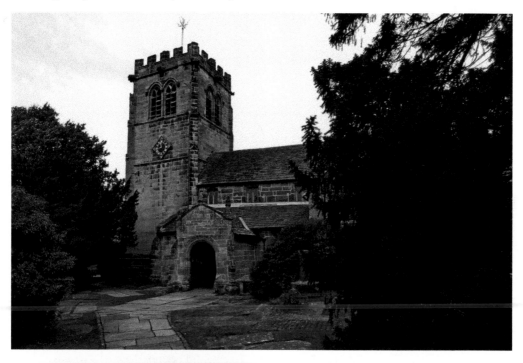

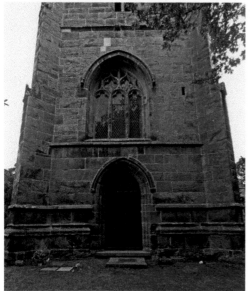

Above: Parish church of St Mary, Nether Alderley.

Left: St Mary's west door and west window.

Based on a design by the architectural partnership of Cuffley and Starkey, the chancel was completely rebuilt in 1856. The work was financed by the Stanley family. Under the direction of the Lancaster architectural firm of Paley and Austin, much of the church was restored between 1877 and 1878. The work included lowering the floor of the nave, replacing the pulpit and replacing the box pews with oak pews.

For many years the Stanley family of Alderley has had associations with the church. There is a Stanley Mausoleum in the church grounds and, at the eastern end of the south aisle, is the seventeenth-century Stanley pew. The pew is at the level of an upper storey and can only be entered from a flight of steps on the outside the church. There are also several monuments to the lords Stanley of Alderley.

In 1598, a bitter feud erupted between two of the leading families in the region – the Stanleys of Alderley and the Fittons of nearby Gawsworth. The dispute related to space within the church. Members of the Stanley family

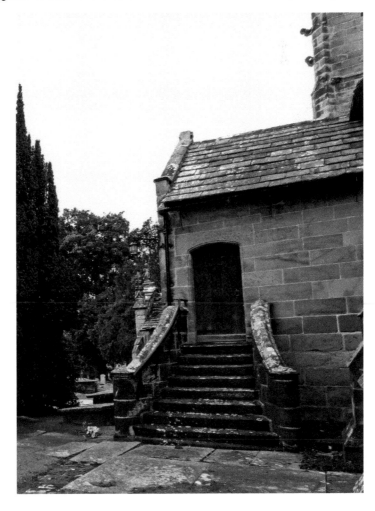

Stairs giving access to the Stanley pew.

claimed that their chapel was 'cut down' during the night of 24 February, the feast of St Matthias the Apostle. The dispute became so intense that the Stanley family suggested that Sir Edward Fitton truly deserved his reputation as 'the Fighting Fitton'. The protracted dispute was finally resolved when the Fittons agreed to use the ground floor of the church and the Stanleys agreed to use the upper floor – hence the Stanley pew being at the level of an upper storey.

Memorials to the lords Stanley of Alderley can be seen in the chancel. The memorial to John Stanley, 1st Baron Stanley of Alderley, by Richard Westmacott depicts Baron Stanley dressed in peer's robes and lying under a canopy with his hand on a book. There is a memorial to his son, Edward Stanley, on the other side of the chancel. The effigy shows Edward holding a scroll in his hand and with a dog at his feet. There are figures of his widow and twelve children on the side of the memorial. Another memorial tablet, by the sculptor Sir Joseph Edgar Boehm, commemorates John Constantine Stanley, who died in 1878. The rector of the parish from 1625 to 1630, Revd Edward Shipton, is also commemorated in a monument in the chancel.

It is thought that the first organ at St Mary's was second-hand. The organ was built in the musicians' gallery at the west end of the church in 1803. As the organ was often in need of repair, it was sold, although offers did not exceed £5. In 1875, a new organ was presented by Lady Fabia Stanley, wife of Henry, the 3rd Lord Stanley of Alderley. The organ was made by William Hill & Son of London, who were one of the most eminent organ builders of the day. It cost £350.

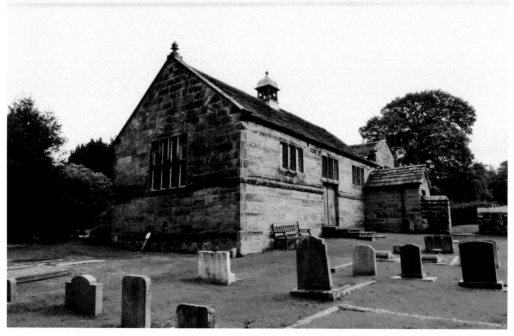

The old sandstone schoolhouse was built in 1628 and is now used as the parish hall.

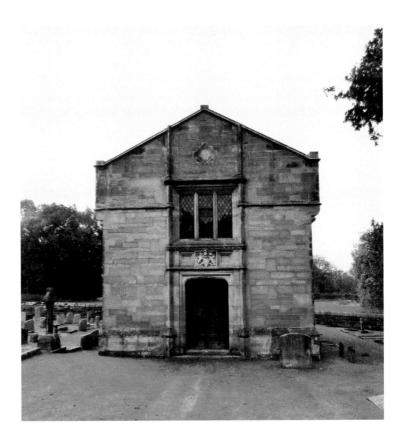

The Stanley
Mausoleum
in the church
grounds, built
in 1909.

Sometime at the beginning of the English Civil War the stone basin of the
church's fourteenth-century stone font was removed from its support and buried
in the church grounds for safekeeping. The font was found when it was dug up in
1821. The basin was, once again, replaced on its pillar and left to stand outside
until 1924 when it was fully restored and returned for use in the church. A second
font had been purchased in 1760 at a cost of £12. This font was replaced some
hundred years later when Blanche Stanley, Countess of Airlie and daughter of the
2nd Lord Stanley, donated another font. When the original font was brought back
into the church, Blanche Stanley's font was stored in the mausoleum.

There are also two Bibles in the church that are of historical significance: a
so-called Vinegar Bible and a rare Breeches Bible. There is an oak document chest
in the tower, which dates from 1686, but, owing to a heated dispute between the
vicar and the churchwardens sometime in the eighteenth century, many of the
ancient church documents were destroyed.

The east window, dating from 1856, is attributed to the stained-glass designer
William Wailes. Morris & Co. designed and installed the glass in the south
window of the chancel. The Greg Window, which is next to the pulpit, was
designed by Irene Shakerley and installed in 1920. The window is dedicated to
Alice Mildred and Thomas Ronald Tylston, aged eight years, wife and only son
of Alexander Greg of Styal Mill. The east window in the north aisle is by Irene

Dunlop. The stained-glass window at the west end of the north aisle is dedicated to the memory of the wife of Edward John Bell, rector of St Mary's from 1870 to 1907. The glass was designed and made by the London firm of Clayton and Bell.

The tower at St Mary's was built in approximately 1540, and by 1549 the church had a ring of four bells. The tower now has a ring of six bells, five of which were foundered in 1787 by C&J Rudhall of Gloucester, with the sixth, by Charles and George Mears, being cast at the Whitechapel Bell Foundry in 1847. There is a seventh, unused, bell which dates from 1686.

In 2007, a vault that was known to be under the church was rediscovered by an architect. When a stone slab was removed it revealed a number of steps leading down to a crypt under the chancel. Inside the crypt were six well-preserved coffins. Three of the coffins were John Thomas Stanley, 1st Lord of Alderley; his wife, Lady Maria Josepha Stanley; and their ninth child, Alfred Stanley. The other three coffins were Edward John Stanley, 2nd Lord of Alderley; his wife Henrietta Maria; and one of their ten children, John Constantine Stanley. When the relevant details had been recorded the crypt was resealed.

The Stanley Mausoleum, designed in the neo-Jacobean style by architect Paul Phipps, was built in 1909 by Edward Lyulph, 4th Lord Stanley. There is a white marble sarcophagus inside the mausoleum, which contains his ashes and those of his wife, Mary Katherine

There is a medieval cross in the church grounds and an ancient yew tree. The sandstone schoolhouse in the churchyard was built in 1628 by Hugh Shaw. The free school was where boys of the parish were taught the basic skills of reading, writing and arithmetic. In 1817, Revd Edward Stanley added a large room at the rear of the building. Then, in 1908, the building was restored and presented to the parish by Lord Stanley of Alderley. The building is now used as a parish hall.

In 1830, body snatchers stole the corpses of two women from the churchyard. The perpetrators of the deed were duly apprehended, but, as the statute book made no reference to body snatching, no crime had been committed. Justice, of sorts, was ultimately served, however, when the body snatchers were charged with stealing wedding rings from the bodies. They were given prison sentences.

Location: SK10 4TW

15. St John the Baptist Church, Chester

The Anglo-Saxon church of St John the Baptist was, traditionally, founded by King Aethelred of Mercia in 689. The church was extended in the tenth century by the Earl of Mercia, whose wife, Aethelflaeda, was the daughter of Alfred the Great. The foundation of the present church is credited to Bishop Peter de Lea, who moved the see from Lichfield to Chester in 1075. St John's became the cathedral church and continued as Chester's cathedral until 1082 when Bishop Peter died. He was succeeded by Robert de Limesey, who immediately transferred the see to Coventry. Then, following the Dissolution of the Monasteries in the sixteenth century, Chester Abbey assumed the status of Chester Cathedral, thus relegating the church of St John the Baptist to that of a parish church.

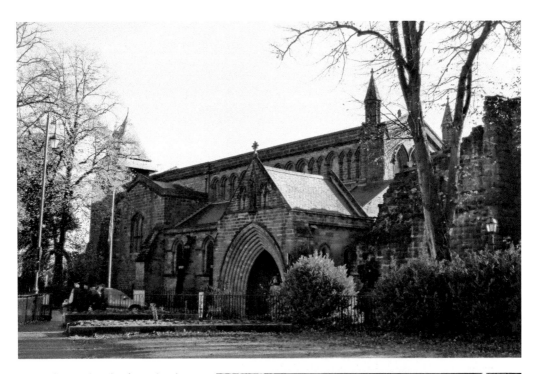

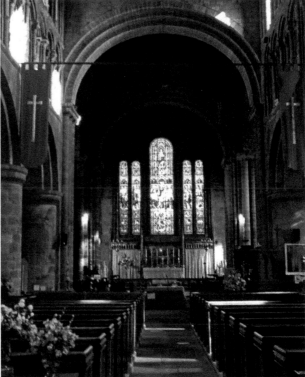

Above: Church of St John the
Baptist, Chester.

Right: Looking towards the
chancel and east window.

In plan, the body of the sandstone church has a five-bay chancel and a four-bay nave with a clerestory. There are north and south aisles and a north porch. At the crossing there are single-bay north and south transepts, with chapels to both the north and south – the north chapel now being used as a vestry. The south chapel is the Lady Chapel, with the chapter house being to the south of the Lady Chapel.

There was a dramatic collapse of the central tower in 1468 and again in 1572. Then, in 1574, the north-west tower collapsed, causing serious damage to four bays of the Norman nave.

During the Civil War, the Royalists held the city for Charles I. However, at the time of the siege of Chester in 1645, Roundhead troops used the church as a garrison and gun platform from which they were able to bombard the city and its walls.

There was a comprehensive programme of restoration carried out between 1859 and 1866, when the church was re-seated, the galleries swept away, the nineteenth century pulpit moved from the centre and the south wall rebuilt. The restoration work was carried out under the direction of the architect, Richard Charles Hussey. During the course of repairs to the tower in 1881 it collapsed again, and on this occasion the collapse destroyed the north porch. The porch was rebuilt between 1881 and 1882 by the Victorian architect John Douglas.

The organ was brought by barge from Westminster Abbey.

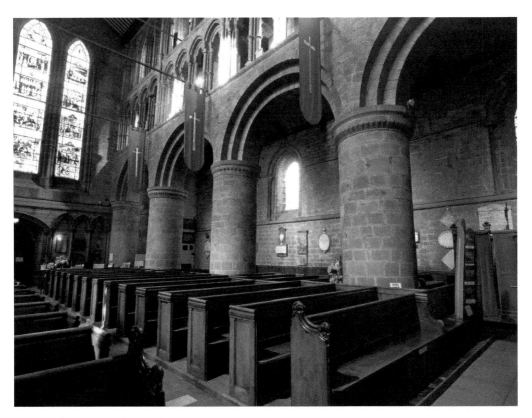

Solid Norman pillars in the nave.

Further restoration was undertaken between 1886 and 1887 when a bell and clock tower, also designed by John Douglas, were erected east of the north transept. The north wall of the church was also strengthened and refaced at this time.

When the Warburton Chapel at the south-east corner of the church was extended in 1925 it was rededicated as the Lady Chapel. Many monuments to the Warburton family still remain, including a late seventeenth-century memorial to Diana Warburton, who died in 1693.

When the Puritan whitewash was removed from the nave pillars in the nineteenth century, a thirteenth-century painting of Christ was rediscovered. The Randle-Holme family is commemorated in a number of memorial boards in the church. There are two fonts in the church: one a red sandstone font dating from the seventeenth century that was only rediscovered in the nineteenth century and another that dates from the fifteenth century.

St John's has two brass chandeliers dating from 1722. The reredos, which was made by Morris & Co. and designed by John Douglas, dates from 1876 and includes a painting of the Last Supper by Heaton, Butler and Bayne.

Built especially, and specifically, by William Hill and Company of London as a temporary organ for the coronation of Queen Victoria in 1838, the organ was completely rebuilt after the coronation. It was then transported by barge from

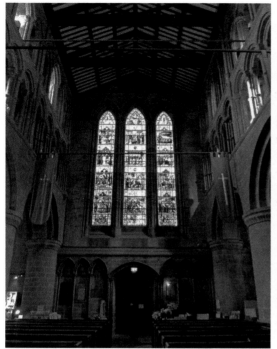

Above left: The great west window.

Above right: Window commemorating Thomas Meakin Lockwood.

Westminster Abbey to Chester where it was installed in the west end of St John's. To celebrate the occasion, the inaugural recital was given by Henry Gauntlett on 28 October 1838. The organ was moved to the south transept during the 1859 restoration programme, then moved again during the 1895 work to the north transept. During this period, a new organ case, designed by the architect Thomas Meakin Lockwood, was installed. Charles Whiteley and Company converted the organ to an electro-pneumatic action in the 1960s. Because of vandalism, further restoration became necessary in 2002.

The east window, which dates from 1863, was designed by Thomas Mainwaring Penson and made by Clayton and Bell. The window commemorates the marriage of Edward, Prince of Wales, and depicts biblical scenes. The great west window, which was commissioned by the 1st Duke of Westminster and designed by Edward Frampton, was not installed until twenty-four years later. The window depicts historic ecclesiastical events in Chester.

There is a wall painting of St John the Baptist in the north aisle. In 1901, the master builders of Chester placed a memorial window, by Shrigley and Scott, in the north-east nave aisle. The window commemorated the architect Thomas Meakin Lockwood and depicted Hiram, builder of the temple at Jerusalem.

Location: CH1 1SN

16. ST PETER'S CHURCH, ASTON-BY-SUTTON

In 1236, Sir Thomas de Dutton built the first religious building in the hamlet, a chapel of ease known as the Chapel of Poosey (or Pooseye). It was not until the latter part of the thirteenth century that the bishop of Litchfield ordered that a chaplain, together with a lamp, should be provided by the prior of Norton Priory. When a domestic chapel was added at Dutton Hall, Poosey Chapel fell into disrepair.

There had been a chapel built on the same site as the present church sometime in the early sixteenth century. The chapel suffered damage during the Civil War but was refurbished by Sir Thomas Aston. His son, Sir Willoughby Aston, commissioned the architect Thomas Webb to build the chancel under the direction of the mason Edward Nixon in 1697. Then, between 1736 and 1740, the nave was reconstructed. In 1857, choir stalls replaced the Aston family pews, and an organ chamber was constructed on the south side of the chancel in 1897. Originally the church had thirteen pews on either side of the nave, with a further ten pews in the gallery. One pew was allotted to Aston Hall menservants, one to Aston Hall maidservants and two were allotted to the choir. The six pews under the gallery were 'free'.

The church, built from local pink Runcorn sandstone, has grey slate tiles on the roof. In plan, the church has a three-bay chancel, nave, north and south porches and a western tower. A door on the north side of the chancel previously led to an area in the churchyard that was solely reserved as a burial place for the lord of the manor and members of his family. The chancel floor dates from the seventeenth

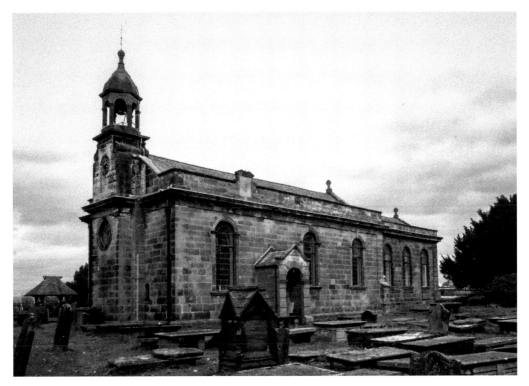

St Peter's from the south-west.

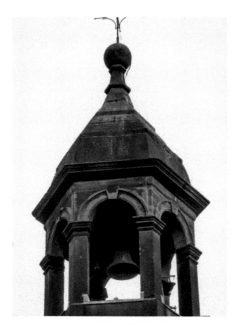

The 'Crescent City' bell.

century and is very distinctive, with squares of white stones and insets of black marble placed at the intersections.

There was a vestry meeting in 1857 when it was resolved to make a number of changes to the fabric of the church. Sir Arthur Ingram Aston GCB generously donated the following: a new organ, which was built and installed by Flight & Son of London; a handsome carved oak pulpit, which is carried on an octagonal stalk; a carved oak baptismal font; a silver Communion service contained in a polished oak box; and a turret clock made by the local company of Handley of Runcorn. Sir Arthur also installed new east and west stained-glass windows and had the chancel re-roofed and a new ceiling inserted.

The church also has an exquisite Jacobean-style holy table, which is the work of the Frodsham woodcarver Robert Harper and bears a marked similarity to the table he carved for St Laurence's Church at Frodsham.

A landmine caused significant damage to the church at the beginning of the Second World War, which resulted in the church having to be closed for some years. Much of the damage was to the south side and the east end of the church. The organ chamber in the chancel was completely destroyed, as was the south porch. The Warrington architects Wright and Hamlyn were awarded the commission to restore the church, and work commenced on 30 May 1949. On completion, the church was re-hallowed on 27 June 1950 by Revd Dr D. H. Crick, Lord Bishop of Chester.

The present organ was built in 1906 by Ernest Wadsworth Ltd of Manchester and installed in the west gallery in 1908. Following the landmine damage, the organ was rebuilt by the Manchester-based organ builders Jardine & Co. Ltd.

St Peter's has just one bell, but there is a very interesting story behind it. According to church records there was a vestry meeting in 1872 when 'The Minister and

Above: Wall-mounted sundial.

Right: War memorial outside of St Peter's Church.

Wardens consented to the old bell belonging to the church being removed to the new Aston School and the bell presented by James Campbell Esquire being fixed in the Church'. In actual fact, the bell presented by James Campbell bore the inscription 'Crescent City 1870' and came from the ill-fated *Crescent City*, a new ship owned by the Liverpool & Mississippi Steamship Company. It had foundered on its return maiden voyage from New Orleans to Liverpool after encountering tumultuous gales and fog. The ship had been specially built at McMillan's Yard in Dumbarton for the New Orleans–Liverpool trade. The ship's name had been taken from the old name of New Orleans, which was Crescent City. During the latter part of the fateful voyage the ship's master misread his sextant, which resulted in the ship being wrecked on Dhuilig Rock in Rosscarbery Bay on the south coast of Ireland.

There are some interesting entries in the Register of Burials, which begins in April 1635. A particular form of burial certificate appears for the first time in 1678 together with an affidavit and certificate. The forms affirmed that the deceased was buried in compliance of the law of 1 August 1678, which dictated that the corpse should be 'buried in neither shirt nor sheet other than should be made

of wooll only'. The law had been passed in a bid to support the home woollen trade and deter imports of foreign linen; however, people belonging to the more affluent classes preferred, and continued, to be buried in linen, and thus incurred the £5 fixed penalty.

The graveyard has a number of interesting graves and headstones, together with inscriptions that perhaps reflect the different social norms of the period. One of the more prominent memorials is that to Chloe Gambia. Chloe, who, after arriving in Liverpool in 1767, spent the rest of her life as a servant in the Aston household, rising to the position of housekeeper. She died of breast cancer in 1838. Her memorial reads:

> Chloe Gambia a negress
> Who died at Aston Hall the 12th
> Sept. 1838 aged 77 years or
> thereabouts. She lived in
> the Aston family 70 years.

Another memorial reads:

> Here lieth the body of
> Mary Illidge wife of John
> Illidge of Aston who died
> March 3rd 1842 aged 58 years.
> She was afflicted with the
> Dropsy and underwent 9 operations
> in 23 months. She had 178 quarts
> of water taken from her during
> that time.

There are two war graves in the churchyard – both of soldiers from the King's Liverpool Regiment who lost their lives during the First World War.

Location: WA7 3ED

17. St Boniface's Church, Bunbury

There have been a number of churches on this site. The earliest was a wooden-framed church from the eighth century; though this was well before the time of the Domesday survey, there was a reference to the church in the Domesday Book. There was a stone-built Norman church on the site, dating from the twelfth century. The Decorated style of architecture was adopted when the church was completely rebuilt in 1320. Further major restoration was carried out by the Manchester architects Pennington and Bridgen between 1863 and 1866, when the old box pews were removed, along with the galleries and a number of wall paintings. At that time the old roof was replaced and the floor tiled. A college of priests at Bunbury was endowed by Sir Hugh de Calveley in 1385. It is believed

that Sir Hugh was very tall, with some estimates suggesting that he stood nearly 7 feet. His alabaster tomb stands in the centre of the chancel. Within the chancel rail, on the north wall of the sanctuary, is an impressive wall monument to Sir George Beeston. Sir George was the commander of *Dreadnought* and, as Admiral of the Fleet, he played a significant role commanding part of the English fleet against the Spanish Armada – reputedly at the age of eighty-nine. According to the inscription on his memorial, he died at the age of 102.

There is a standing effigy of Jane Johnson in the north aisle. It is said that the monument was ordered to be buried on the instructions of a previous incumbent, as he was, apparently, disturbed by the fulsome curves of the effigy!

The carved fourteenth-century stone reredos in the north aisle includes a Green Man, symbolising rebirth and fertility.

Sir Ralph (Raufe) Egerton of Ridley commissioned the chantry chapel, also known as the Ridley Chapel, to be constructed in 1527. The chapel is separated from the chancel by a carved stone screen.

A preacher and a curate were endowed in Bunbury when Thomas Aldersey acquired the church's tithes and advowson. Puritan ministers were appointed, including the English priest and author William Hinde.

The chantries were dissolved during the Reformation, and the church reverted to the Crown in 1548. Then, at the 'Bunbury Convention' of 1642, the county of

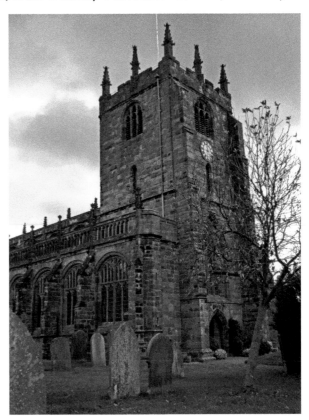

Parish church of St Boniface, Bunbury.

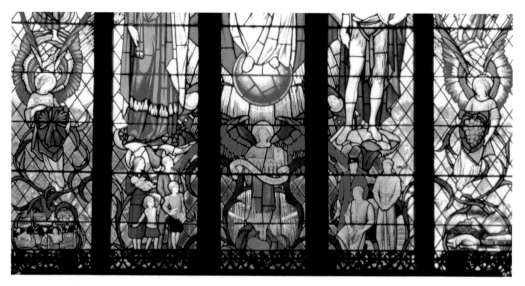

Detail of the new east window, depicting some figures in contemporary dress.

Cheshire was declared to be neutral in the argument between Parliament and the sovereign. However, that neutrality was brought into question when the church became the object of Royalist fire, which inflicted heavy damage.

St Boniface has a six-bay nave, with eight-bay north and south aisles enclosing the west tower. The tower is surmounted by battlements and pinnacles. The three-bay chancel leads to the sanctuary with a vestry to the north and the Ridley Chapel to the south of the chancel. There are windows in the north chancel wall by R. C. Evetts, and the south chancel wall has windows by Charles Eamer Kempe.

A bomber, returning from a raid on Liverpool in 1940, dropped a landmine which caused significant damage to the church and blew out many of the windows. Restoration took many years and much fundraising. The new east window, from the Orchard House Studio of Christopher Webb at St Albans, shows many characters in 1950s clothing. The roof was replaced under the direction of the architect Marshall Sisson. The west window and the glass in the east window of the north aisle is also by Christopher Webb.

There are many ancient artefacts in the church, including the stone font (which dates from 1662) and the oak Communion rail (which dates from 1717). The pulpit and choir stalls are also of carved oak. There are some fragments of wall paintings remaining in the church. The more recent chancel screen is by Frederick Herbert Crossley.

The church has a ring of eight bells, the first two dating from the early sixteenth and early seventeenth centuries. Rudhall of Gloucester then cast a further two bells, the first in 1715 and the second in 1758. The four later bells were all cast in the Whitechapel Bell Foundry, the first being cast by Thomas Mears II in 1817, and the last three being cast by Mears and Stainbank – the first two in 1895 and the last one in 1898.

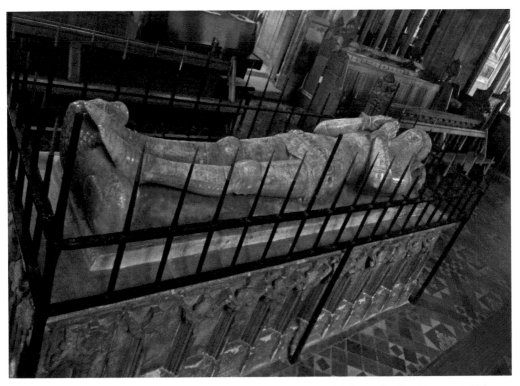

Above: Alabaster tomb of Sir Hugh de Calveley.

Right: Font at St Boniface.

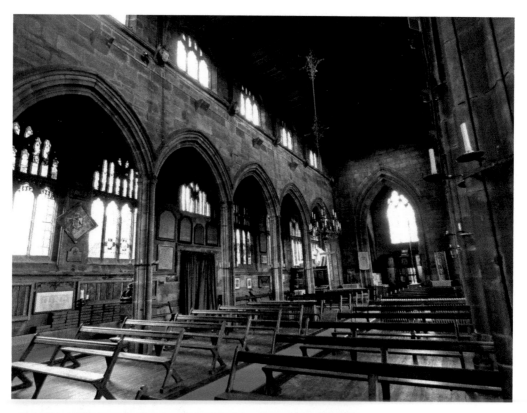

Above: Six-bay nave at
St Boniface.

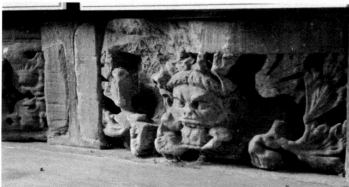

Left: Detail of carved
fourteenth-century
reredos.

Conachers of Huddersfield built the organ in 1895, which was later extensively rebuilt by Henry Willis & Sons in 1968.

In the churchyard there is a red sandstone sundial which dates from 1710. The old churchyard also has the war graves of five soldiers from the First World War, and in the extension to the graveyard there are the graves of four soldiers and a naval officer who died during the Second World War.

Location: CW6 9PE

18. ST MARY'S CHURCH, ROSTHERNE

The Domesday Book makes no reference to there being a church at Rostherne, but reference is made in a deed of 1188 to there being an endowed church on the site.

The parish church of St Mary's, Rostherne, has a four-bay nave with side aisles and also a four-bay chancel with side chapels and a vestry. The three-stage tower has a clock face on the south side.

The first steeple was built in 1533, but after some years of neglect the steeple collapsed in November 1741. The collapse of the steeple also caused significant damage to the fabric of the church itself. The architect John Rowson was responsible for building the church and tower; the work was carried out between 1742 and 1744. The south porch was added in 1886. Sir Arthur Blomfield designed the chancel and north vestry, which date from 1888. Wilbraham Egerton, 1st Earl Egerton, commissioned the restoration of the church in 1888 in memory of his father, Baron Egerton.

The Gothic style of architecture is the predominant style on the inside of the church, although other styles are evident. When the tower fell in 1741 an effigy of a recumbent knight was found, which probably dates from the reign of Henry III.

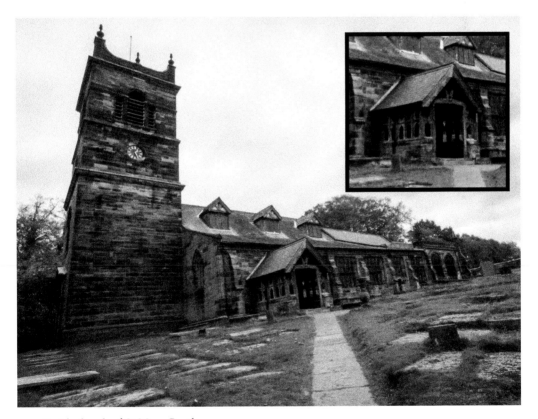

Parish church of St Mary, Rostherne.

Inset: South porch at St Mary's.

One of the most poignant memorials in the church is in memory of Charlotte Lucy Beatrix Egerton, who on the eve of her wedding in 1845 drowned in Rostherne Mere. The memorial, by the English sculptor Richard Westmacott III, shows a recumbent Charlotte with an angel stooping over her.

John Bacon, another leading British sculptor, fashioned the monument to Samuel Egerton and also the monument to Jonas Langford Brooke. There are several other monuments in the church commemorating some of the leading families of the region, including the Cholmondeley, Venables, Brooke, Leigh and Egerton families.

Alexander Young & Sons of Manchester built the organ in 1906, which was reconstructed between 1970 and 1979 by George Sixsmith & Son Ltd of Mossley, Lancashire.

St Mary's has a ring of six bells, the two earliest dating from 1630 and 1655 respectively. The later four bells were founded by Rudhall's of Gloucester between 1717 and 1785.

The lych gate outside the church, with its unusual self-closing mechanism, dates from 1640 and is thought to be a forerunner of the revolving doors often found in hotels. The mechanism, which was specifically designed to keep animals out of the churchyard, closes automatically by a weighted cord that passes around a wheel at the top. The sandstone Simpson tomb, dating from around 1831, can also be found in the churchyard. There is a sundial in the churchyard, which dates from around 1730, and a Celtic head carved into a block of sandstone with either hair or horns on either side of its face. According to legend the stone head, which was found in Rostherne Mere, is Cernunnos, a Celtic deity from which the Celtic tribe of Cornovii tribe took their name. The churchyard also has the war graves of five soldiers who lost their lives during the First World War.

This sundial dates from 1730.

The Simpson tomb, dating
from 1861.

One of the more fanciful legends relating to St Mary's concerns a bell being
delivered to the church. It is said that the workman whose task it was to deliver
the bell to the church was dissatisfied with his role, so cursed the bell. Then,
without any prior warning, he was thrown into the mere, where he drowned. The
bell rolled into the mere shortly after him and neither the bell nor the workman
were ever seen again.

Location: WA16 6RZ

19. ST LUKE'S CHURCH, HOLMES CHAPEL

Built in 1430, the present St Luke's Church of Holmes Chapel was originally a
timber-framed building with a Perpendicular west tower. It is known that there
had previously been a church on the site, and some believe St Luke's to have
been built on the site of a former place of pagan worship, although there is no
verification for this. What can be validated, however, is the fact that in 1265 the
abbot of Dieulacres Abbey authorised the abbot of Chester to hold services in the
'Chappell at Church Hulme'. Then, in the 1430s, the Needham family funded
the building of a new black-and-white, timber-framed church. Owing to marked
deterioration, the nave and chancel were clad in brick in 1705. During the same
period the roof was raised in order to accommodate a gallery being added on the
south side of the building – gifted to the parish by Thomas Hall.

The church has a four-bay nave with both north and south aisles. The single-bay chancel has a lower roof. The tower has an embattled summit with gargoyles at each corner. There are diamond-shaped clock faces on both the north and south sides of the tower. The timber roof dates from the fifteenth century and was revealed when a later plaster ceiling was removed. Near to the Communion rail is a carved oak crest dating from 1622.

The brass candelabrum dates from 1708. The first pulpit was installed in 1723, but was replaced in 1853 by the present oak Victorian pulpit. The pulpit was moved to its current location in 1971. William Joseph Stanier presented the stone font to the church in 1890. There were two earlier fonts: a font dating from 1839 that had been presented by Revd John Armitstead and an earlier one presented by Mr Morfitt. The sanctuary oak panelling dates from 1732 when the chancel itself was extended. The arms of the Winnington family are carved on the south wall together with the initials 'H.W.' and the date '1622'. There is a similar panel, the Cotton panel, over the inner west door. The purpose of the panels is not known.

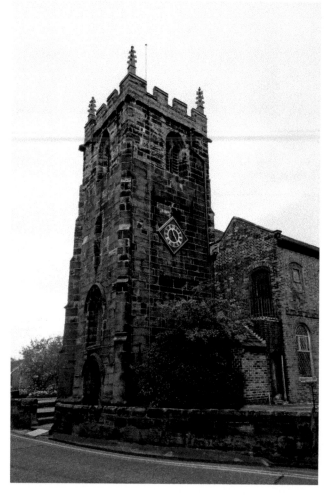

Parish church of St Luke's, Holmes Chapel.

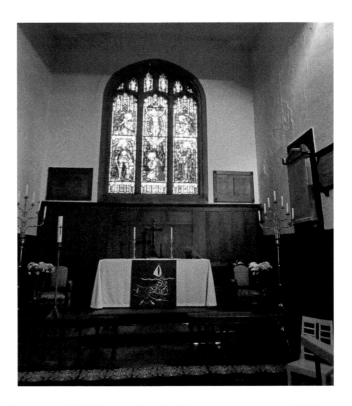

St Luke's altar and east window.

There is a tablet at the west end of the south aisle that commemorates William Arthur Hodges, captain in the 47th Regiment. Captain Hodges was wounded on two occasions in the Battle of Vittoria, and subsequently fell at the storming of San Sebastián in 1813.

The Lady Chapel, located in the south east aisle, is dedicated to Revd John Vernon Culey who was vicar at St Luke's from 1946 to 1969. Given by an anonymous donor, the late Victorian window was installed in 1977. The window depicts three of the angels of creation.

The stained glass in the east window, dating from 1921, is attributed to the English painter and designer Horatio Walter Lonsdale. The window was installed in memory of the service personnel who lost their lives in the First World War. Depicted in the north light is the Angel of Pain holding the Cup of Sorrow and below is Archangel Michael, the warrior. Depicting 'the Supreme Sacrifice', the centre light is a depiction of Christ on the cross with his mourning mother at his feet. The Angel of Pity and, below, Archangel Raphael, the healer, are depicted in the south light. In 2013, the window was temporarily removed for restoration.

The original organ, a barrel organ, was installed in 1816. It was replaced by a pipe organ in 1851 by Richard Jackson. In order to commemorate the golden jubilee of Queen Victoria on 20 June 1887, a new pipe organ was installed in 1888. In 1971, the organ was rebuilt by L. Reeves with parts from the earlier instruments. In addition to the rebuilding, the organ was relocated to the centre of the west gallery. However, over succeeding years, the organ's general condition

deteriorated, and expert opinion suggested that the instrument was beyond repair. Quite fortuitously for St Luke's, a 1970 Rushworth & Dreaper pipe organ became available from the Church of the Good Shepherd in Heswall as, sadly, that church was due for demolition. Before being installed at St Luke's, the organ was refurbished by a specialist organ builder.

St Luke's has a total of seven bells, six of which were originally cast by Richard Sanders and date from the early eighteenth century. One bell was recast at the Whitechapel Bell Foundry in 1858 and the original inscription replaced by the founder's name: G. Mears of London. The seventh bell was cast by the same firm and bears the same date and inscription. Dated 1706, the smallest bell is known as 'the Dagtail' or 'Draggletail Bell'. Traditionally, the bell would have been rung at six in the morning and again at six in the evening so that field workers would be aware as to when to begin and when to finish work. The epithet 'Draggletail' stems from the derisory term originally given to last-minute stragglers arriving at church services who were colloquially known as 'Draggletailers'.

The bells were given to the church by the owner of Cranage Forge, Daniel Cotton.

In the churchyard extension there is a war grave of a soldier who lost his life during the First World War.

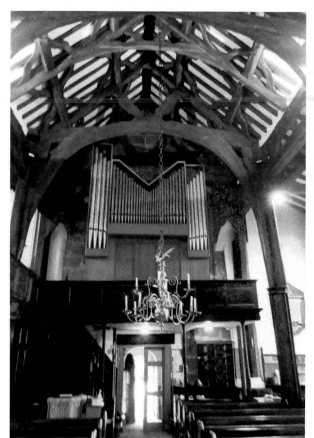

Above: The brass candelabrum dating from 1708.

Left: Looking towards the newly installed organ.

The stone font presented by William
Joseph Stanier.

On 26 December 1643, St Stephen's Day, there was a confrontation in the town
between Royalist and Parliamentary soldiers. The Parliamentarian troops were
marching from Nantwich towards Middlewich, Holmes Chapel and Sandbach
when they encountered the Royalist troops. Shots were exchanged and two men
were fatally wounded; the marks left by the musket balls are still visible in the
brickwork on the north side of the church tower.

Location: CW4 7AG

20. ST MARY'S CHURCH, ASTBURY

Although the Domesday survey makes reference to there being a priest in Astbury,
no mention is made of there being a church in the village, which at the time was
known as Newbold. Just above a doorway in the north-west corner at the rear of
the church there is part of a Saxon cross shaft, which dates from the late tenth or
early eleventh century. Some of the other articles found in and around the church
include fragments of stone and a number of coffin lids, which would suggest
that there was a timber-framed Saxon church on this site before the Norman
Conquest. It looks as though, sometime in the thirteenth century, the east end of
the church was rebuilt in stone and included the building of a chancel, sanctuary
and a tower. However, the tower, which is separate from the main body of the
church, was not constructed in the usual place at the west end, but built to the
north of the west bay of the north aisle and joined by a passage with a porch. This
work was completed during the fourteenth century, with a south porch also being
added at that time. The tower is in three stages, with the lowest stage having a

Romanesque-style doorway on the west side and a Perpendicular-style porch on the left of the east side. There is a two-light window on the west side of the middle stage with a circular clock face above it. There is a priest's room incorporated into the top storey with a two-light louvred bell opening on each side.

The church has a number of different architectural styles, including elements of Norman, Early English, Decorated and Perpendicular, indicating that it was built over a long period. The floor plan is somewhat different from more traditionally built churches, with the west end of the church being some 8 feet wider than the east end, forming more of a trapezium rather than the more conventional rectangle. There are north and south rectangular aisles and a seven-bay nave and chancel without any division.

There was some further rebuilding towards the end of the fifteenth century, with the work being completed in the early part of the sixteenth century. During the building work a clerestory was added as were south and north arcades.

There are a vast number of memorials in the church, including the fourteenth-century tomb of the recumbent Ralph Davenport. There is also the tomb chest of Lady Egerton, who died in 1599. Among many other items of furniture in the church are two sanctuary chairs and a number of old chests, one of which is bound with iron straps and dates from the thirteenth century. In all probability, this chest was used to store important church documents and other church treasures.

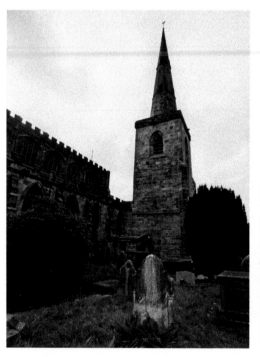

Above left: Parish church of St Mary, Astbury.

Above right: Eighteenth-century octagonal sundial.

The Lady Chapel is at the west end of the south aisle. There is an effigy of a fourteenth-century knight in the chapel. The chapel on the north side is dedicated to St Mary. Dating from 1500, the chancel rood screen separates the nave and chancel, and tall columns reach upward to the camber-beam roof. The screen has a number of carvings, including roses, birds, vines and foliage.

The church was not immune to depravation and damage during the Civil War. At one time, during the siege of Biddulph Hall in January 1643, Sir William Brereton (a prominent Cheshire Puritan) and his many followers made Astbury their headquarters. They stabled their horses inside the church, causing severe damage to the medieval glass windows. And, in order to gain enough room for the stabling, they also removed a number of the furnishings, including the church's organ. Following the wanton smashing of the medieval stained-glass windows, the vicar collected many of the fragments and, fortunately, they were able to be reassembled.

The Jacobean-style octagonal pulpit, the altar rails, the box pews, the reredos in the Lady Chapel and much of the other furniture in the church date from the seventeenth century.

The chancel reredos, which dates from 1866, was designed by the Manchester architect Joseph Stretch Crowther. The eagle lectern is, reputedly, one of the oldest remaining eagle lecterns in the country.

In both aisles stained glass in the west windows dates from the early sixteenth century, whereas much of the other stained glass in the church dates from the Victorian era. The stained-glass designer William Warrington is credited with designing both the east window and the window at the east end of the north aisle, whereas the east window in the south aisle is by Ward and Hughes. The two westernmost windows in the south aisle were designed by Michael and Arthur O'Connor.

The noted architect Anthony Salvin directed some restoration work in the early part of the nineteenth century. There was more remodelling and refurbishment carried out in 1852 under the direction of George Gilbert Scott. A number of paintings were revealed on the walls when whitewash had been removed; one depicted the Blessed Virgin Mary knighting St George.

There is a ring of eight bells at St Marys. Bells 3 to 8 date from 1925 and were cast at the foundry of John Taylor & Co. of Loughborough, although the bells themselves were recast from four of the original ones. Bells 1 and 2 were cast in 1998 at Taylor's foundry.

The pipe organ, a 'Battleship' Binns, was originally built as a four-manual concert organ in 1912 by the organ builders James Jepson Binns of Leeds, and installed in King's Hall, Stoke-on-Trent. The council presented the organ to the church in 1962, after it had been rebuilt as a three-manual and installed by Reeves and Merner. Further restoration was carried out in 2005 by David Jones of Lincoln, after which the organ was relocated to a platform above the vestry.

The yellow sandstone arch, which forms the gateway to the church, dates from the seventeenth century; it has crocketed pinnacles and a battlemented parapet. The graveyard also has over fifty gravestones dating from the seventeenth century. Among these is a thirteenth-century canopied tomb. Opinion is divided as to whose tomb it actually is; it could be a memorial to a member of the Venables family, or it might commemorate the service to the parish of Sir Ralph Brereton.

Left: Thirteenth-century canopied tomb.

Below: Seventeenth-century yellow sandstone gateway to the church.

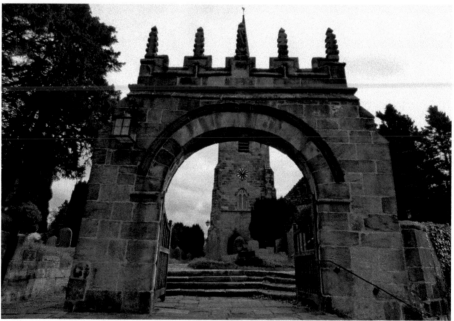

Previously inside of the church, the tomb, which is unique in Cheshire, shows two figures with their hands clasped in prayer. To the north of this there is another tomb from the medieval period, fashioned from yellow sandstone and showing a recumbent cleric with his hands in prayer. Similarly, to the south there is another tomb, also fashioned from yellow sandstone, with a depiction of a knight in full armour.

Right: War memorial.

Below: The 1,000-year-old yew tree in the church grounds.

The sundial in the churchyard is octagonal in form, with two octagonal steps at the bottom that support the eighteenth-century octagonal pillar. A yew tree in the church grounds is reputed to be over a thousand years old.

There are the war graves of sixteen British service personnel in the graveyard: fifteen troops who lost their lives during the First World War and one who fell during the Second World War.

Location: CW12 4RQ

21. ST MARY'S CHURCH, NANTWICH

St Mary's Church, Nantwich, is often described as being the 'Cathedral of South Cheshire'. Originally there was a chapel of ease on the site, which was in the parish of Acton. At the beginning of the twelfth century the church at Acton and the chapel at Nantwich both came under the direct control of the Cistercian abbey of Combermere.

Building started on the present church at Nantwich in the mid-fourteenth century and followed the contemporary Decorated style of the period, employing Yorkshire masons for the workforce and using local Eddisbury sandstone as the primary building material. For the first nine years building progressed at a satisfactory pace, but then in 1349 work was halted due to an outbreak of the

 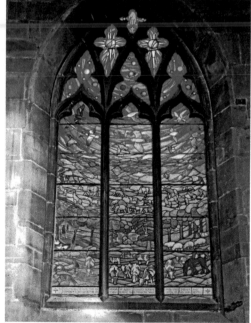

Above left: St Mary's octagonal, pinnacled tower.

Above right: Stained-glass window in memory of Albert Stanley Bourne.

Black Death in the area. Building work resumed towards the end of the century, when the town had recovered its economic prosperity. By this time, however, there was a different workforce and a different architectural style being adopted. The masons were brought from Lichfield and Gloucester cathedrals and construction now followed the Perpendicular style of architecture. In 1405, the south transept was endowed as a chantry chapel.

Many additions were made to the church between the end of the fifteenth century and the beginning of the sixteenth century. The roof of the nave was raised and the clerestory windows were inserted, and the south porch was also added at this time. As a direct result of the Dissolution of the Monasteries, the six chantry chapels were removed in 1548. Somewhat later in the century the transept ceilings were renewed and at the beginning of the seventeenth century the church floor had to be raised because of flooding. There was a period during the Civil War when the church was used as a prison for Royalist troops who had been captured at the battles of Nantwich and Preston.

Built in a typical cruciform shape, the church has a four-bay nave with north and south aisles and a three-bay chancel, to the north of which is a two-storey treasury, a south porch with two storeys, north and south transepts and an unusual central tower, which is square at its base and octagonal above. Both the north and south transepts have three bays. In the north transept the northernmost bay was formerly known as the Lady Chapel, and the other two bays are dedicated to St George. The south transept is known as the Kingsley Chapel. The choir has a lierne-vaulted ceiling. Towards the end of the fourteenth century, oak from the Vale Royal estate was used to fashion the intricately carved choir stalls. There are carved wooden canopies over the choir stalls and twenty misericords at the back of the stalls. The misericords – ten on the north side of the chancel and ten on the south side – are reputed to be among the finest in the country, with the exquisitely carved subjects ranging from a devil pulling a woman's mouth open as punishment for lying, to a man taking a cock to a cockfight. There are also more traditional carved symbols, such as St George battling a dragon. One of the more famous carvings depicts the face of a priest on the rear of a bird. It is considered by many that this carving gives rise to the expression 'the parson's nose', when talking of the rump of a roast chicken.

The north and south galleries, together with a new west door, were added during the eighteenth century. But, due to a number of factors, it became apparent that the church itself was in need of extensive restoration and refurbishment. Between 1855 and 1861, under the direction of Sir George Gilbert Scott, a number of significant changes were made to the fabric of the church: the floor level of the church was lowered and the transept roofs were pitched higher. Many of the older memorials were removed, as were the box pews and the galleries. Sandstone from the local quarry at Runcorn replaced eroded stone in the building. Some further major structural work was carried out on the church 1878 when, under the direction of local architect Thomas Bower, the south porch was restored.

St Mary's has a rare fourteenth-century stone pulpit, which is fashioned in the Perpendicular style. There is also an early seventeenth-century Jacobean wooden

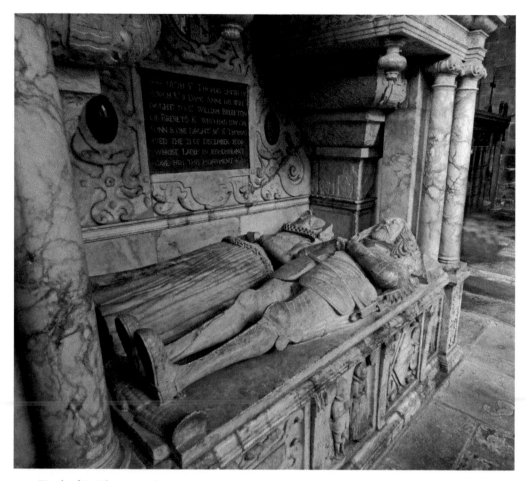

Tomb of Sir Thomas and Dame Anne Smith.

pulpit designed by Thomas Finch. The pulpit was once part of a three-decker pulpit that was damaged by a falling beam in 1683. There is a highly decorated octagonal font near to the church's entrance door.

Two of the many historical artefacts that are to be found in the transept at St Mary's are a bench that dates from 1737 and a large bread chest, or dole chest as it is sometimes referred to. The chest dates from 1676 and was used to store bread, which was distributed after Sunday services to poor people living in the parish.

The painting *The Widow's Mite* by the French-born painter Augustus Jules Bouvier is in the south aisle.

The former Mayor and Sheriff of Chester, Sir Thomas Smith, is commemorated in a memorial in the south transept erected by his wife, Anne Smith. Her effigy was added at a later date. The tomb, dated 1614, was transferred from the former St Chad's Church, Wybunbury, in 1982. There is also an effigy of Sir David Craddock, which can also be found in the south transept. The original

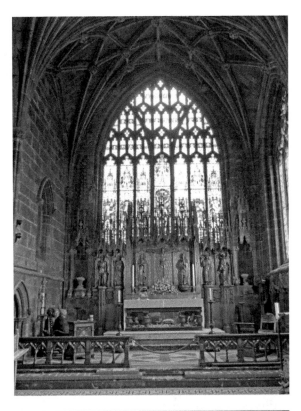

Right: East window.

Below: Bread chest.

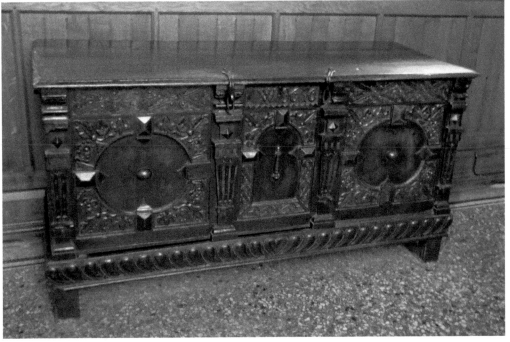

fourteenth-century tomb chest was damaged in the Civil War and later found
buried under the chancel floor.

The stone vaulting in the porch dates from 1879, within which is a carving
of the Green Man. On the outside of the porch there are carvings of the four
evangelists.

The magnificent Jubilee curtains, made by the church's Tapestry Group, are to
be found along the west wall at the back of the church. The curtains commemorate
the silver jubilee of Queen Elizabeth II in 1977.

There are many stained-glass artists who have contributed to the vast
number of stained-glass windows in St Mary's. There is a stained-glass window
in the south transept by William Wailes that dates from 1855. The workshop
of Clayton and Bell installed the west window in 1875 which depicts the
Presentation of Jesus at the Temple. The workshop also installed the window
at the west end of the north wall of the nave which depicts Enoch, Noah, Job
and Abel, and the re-glazed the east window in 1876 depicts scenes in the life
of Christ.

A window in the north wall of the north transept is attributed to Charles
Eamer Kempe and depicts the tree of Jesse. In the porch there is another window
attributed to Kempe, which dates from 1878. There are also two windows by

Misericord – detail of St George battling a dragon.

Part of the jubilee curtain.

John Hardman on the east wall of the north transept dating from 1862 and 1864 respectively.

In 1919, a stained-glass window was inserted on the south wall of the nave. The window is by Harry Clarke and depicts Richard Coeur de Lion ('the Lionheart'.

A local farmer, Albert Stanley Bourne, is commemorated in a window designed by Michael Farrar-Bell and installed in 1985. Another window nearby was designed by Reuben Bennett and depicts the Good Shepherd with David and Miriam.

The original organ was installed in 1809, but no records remain as to the identity of the organ builder. When the organ was moved during Sir George Gilbert Scott's restoration and refurbishment from its central location in the crossing to the north transept, it became apparent that the instrument had suffered due to the move, and that the cause was most likely to have been cold and damp in the new location. The organ was moved again to the south transept, but there was no significant improvement in its performance. In 1889, the organ was sold to St James' Church, Haydock, for £100. A new organ was built and installed by Forster and Andrews of Hull in 1890 and partly rebuilt sometime early in the twentieth century. In 1946, and again in 1973 and 1985, Charles Whiteley & Co. of Chester made improvements to the organ, then in 1994 the organ was rebuilt by Rushworth and Dreaper of Liverpool.

St Mary's has a ring of eight bells. The original six bells were cast in the foundry of Abraham Rudhall of Gloucester in 1713. In 1922, the original six Rudhall bells were removed from the tower and taken to the foundry of John Taylor in Loughborough. Two of the existing bells were recast and two new bells were cast, making for a total ring of eight bells. The bells were retuned before their return to Nantwich and rehanging in a new cast-iron frame.

Location: CW5 5RQ

ACKNOWLEDGEMENTS

I would like to record my thanks to the many people who have assisted me in collecting and collating information with regards to the historic churches recorded in this text, especially the churchwardens and other church members of several churches who extended to me some very timely help and assistance. I would also like to thank the many library staff from various libraries across the county who gave me their time and valuable assistance. And to Yvonne Janvier, who gave me an insight into the history of St Luke's Church, Holmes Chapel. I would especially like to thank my wife, Janet, for accompanying me when taking photographs of the various churches mentioned in the text; to my brother, Colin, for processing many of the photographs; and also to my son, Jon, who read and made a number of useful corrections to the manuscript.

Finally, while I have tried to ensure that the information in the text is factually correct, any errors or inaccuracies are mine alone.

ABOUT THE AUTHOR

David Paul was born and brought up in Liverpool. Before entering the teaching profession David served as an apprentice marine engineer with the Pacific Steam Navigation Company. Since retiring, David has written a number of books on different aspects of the history of Derbyshire, Cheshire, Lancashire, Yorkshire, Shropshire and Liverpool.

ALSO BY DAVID PAUL

Eyam: Plague Village
Anfield Voices
Historic Streets of Liverpool
Illustrated Tales of Cheshire
Illustrated Tales of Yorkshire
Illustrated Tales of Shropshire
Illustrated Tales of Lancashire
Illustrated Tales of Derbyshire
Speke to Me
Around Speke Through Time
Speke History Tour
Woolton Through Time
Woolton History Tour
Churches of Derbyshire
Churches of Lancashire
Churches of Shropshire